rie muñoz

ARTIST IN ALASKA

Introduction by
Sarah Eppenbach

Text by
**Peter Metcalfe,
Rie Muñoz**

Rie Muñoz, Ltd., Publisher
Juneau, Alaska 99801

Rie Muñoz
Artist in Alaska

Front cover: "The Last Caribou," watercolor, 1979
Back cover: "Russian Church, Unalaska," watercolor, 1986

First Printing: 1987

Muñoz, Rie
 Rie Muñoz, artist in Alaska.

 Includes index.
 1. Muñoz, Rie--Catalogs. 2. Alaska in art--
Catalogs. I. Metcalfe, Peter, 1951- . II. Title.
N6537.M86A4 1987 709'.2'4 87-20517
ISBN 0-9618565-0-5

Design: John Fehringer Design
 Juneau, Alaska

Rie Muñoz, Ltd., Publisher
Juneau, Alaska, 99801
Telephone: (907) 586-2112

Typesetting: The Type Shop
 Juneau, Alaska

Printed in Singapore

rie muñoz

ARTIST IN ALASKA

Rie Muñoz, Ltd., Publisher
Juneau, Alaska 99801

Dedicated to

Adele Hamey and Juan P. Muñoz

Table of Contents

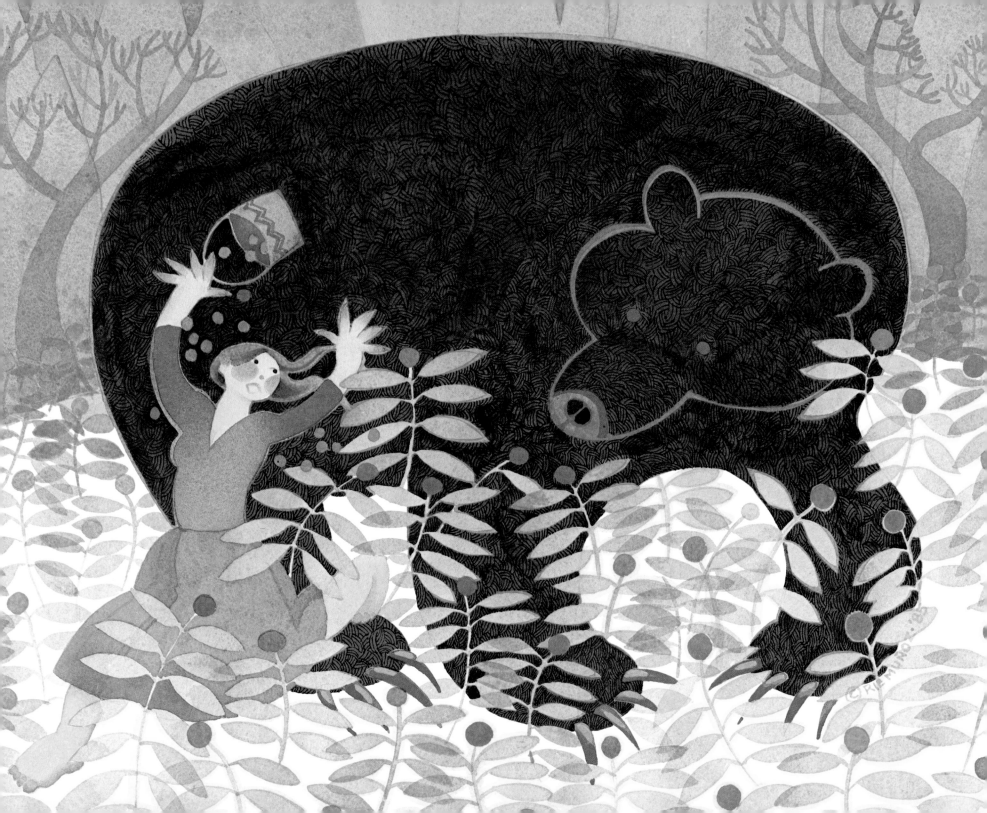

Woman Bear Legend

Two women went up to the mountain every day to snare squirrels. One woman got squirrels every day, but the other always stopped at a clearing part way up the mountain and ate berries all day long. Finally, one evening, as the woman came down to the clearing with her day's harvest, she saw her partner on all fours, eating berries. As she approached, she saw her partner turn into a black bear.

From the book *Dena'ina Sukdu'a,* as told by Antone Evan, gathered and translated by Joan M. Tenenbaum.

Woman Bear Legend
16" X 13"
1981

Introduction

One summer morning in 1982, the stubborn cloud hanging over Juneau parted long enough to allow Rie Muñoz, my husband and me, and Buddy-Pierre (the black-and-white Labrador/Saint Bernard seen frolicking through many a Muñoz painting) to make the forty-minute flight by bush plane to Elfin Cove on Chichagof Island. By any conceivable criteria, Elfin Cove is one of the most beautiful spots in all of Alaska. There is a diminutive natural harbor framed by tall dark spruce and rock cliffs, a fishing village clinging to a wooden boardwalk, and a view of mountains as pure and stern as white-cassocked priests—the type of scenery, in other words, that artists weep for the chance to paint. And where was Rie amid all this splendor? Sketching salmon heads at the fishbuyer's dock.

Some months later, I saw the fruits of Rie's visit in a painting titled "Fish Buyer, Elfin Cove." In the painting there are no gleaming mountains, idyllic cove, or rustic boardwalk. The frame is filled with fiberglass totes layered with salmon, the bucket scale with its round clock face, and the impatient, squabbling seagulls that are almost a Muñoz signature. The fishbuyers, wearing the black rubber boots we call "Alaskan tennies," are shoveling ice over the fish and scrubbing the totes with a long-handled brush. It's a view not of Elfin Cove, the place; but Elfin Cove, *the life.*

History has blessed us with countless artists who have cast aside "noble" subjects like landscapes in favor of chronicling the life around them. In fact, the first one I recollect encountering, the 16th-century painter Pieter Bruegel the Elder, lived not far from Rie's ancestral Holland. Bruegel's canvases positively seethe with busy people. There are harvesters reaping, children playing ball, butchers skinning hogs, dogs scuffling, and waiters hurrying platters of food to a wedding feast. Every canvas is a wonderful window into Flemish life.

A century later, the Ukiyo-e artists began depicting the same sort of everyday scene in their colorful woodblock prints, giving us valuable insight into the dress and customs of mysterious Japan. And thanks to Toulouse-Lautrec's vivid posters, we can visualize the bawdy cafe scene around Montmartre in the late 1800s, *knowing* the characters. . .hearing the music and the throaty laughter. . . smelling the cigar smoke and brandy fumes. Such is the power of art.

Alaskan artist Rie Muñoz is cut from the same cloth. She dazzles our eyes with color and fanciful shapes, all the while recording the Alaska she feels is "disappearing very fast." Crowded with authentic Alaskan figures such as Indian berry-pickers or Eskimo hunters; lively with caribou, whales, geese, and other northern creatures; Muñoz's serigraphs and paintings are documentaries on a lifestyle that is undergoing dramatic flux.

We see Eskimo women ice fishing, picking berries, skinning a seal, and playing cat's cradle; Tlingit Indians gathering spruce roots for weaving baskets, or harvesting seaweed covered with sticky herring eggs. We see commercial fishermen hauling in crabs, putting to sea in trollers, and selling halibut to waiting fishbuyers. Fish camps and canneries, Russian churches and storefront cafes, cemeteries and clotheslines are all immortalized in places like Elfin Cove, Tenakee Springs, Gambell, Angoon, Nunivak, King Island, Naknek, Mekoryuk, Sigik, Nome, Hoonah, Unalaska, Buckland, and Shishmaref. The titles of Rie's paintings read like an atlas of all the out-of-the-way hamlets that make up the rich embroidery of Alaskan life.

This celebration of the Alaskan lifestyle appeals enormously to Alaskans. From villagers in remote bush communities to government workers in high-rise Anchorage, Alaskans have only to look

at the lively vignettes to see themselves (in many cases quite literally)—not in a manner that is patronizing, or glorifying, or ridiculing, or romanticizing—but as they are, in a style as bold and straightforward as Alaskans themselves. But how to explain Rie's equally strong appeal in the Lower 48? "It's her style!" says Kay Greathouse, Director of the Frye Museum in Seattle, where patrons have stood in line to get into a Muñoz exhibit. "It's her color; the whimsy she puts in her art. She's in her own class with her own individuality, and that's what people like."

Vigorous color, compelling motion, an accent on people...these are the hallmarks of a Rie Muñoz painting. The effect on the viewer is much like the impact of Rie herself: bright, breezy, captivating. It's as if her art were a natural extension of her disposition. While the style is indeed whimsical, at times harking back to Rie's days as a cartoonist for the *Daily Alaska Empire*, the art carries the authority that comes with authenticity. The viewer knows intuitively that this artist has not only been to the location, but understands it; not only understands it, but is in tune with the subject matter.

Look at her "little fat Eskimo ladies," as she calls them—bundled in sealskin mukluks and calico-covered caribou parkas, as graceful as doves. To me they are the quintessential Rie Muñoz. Stooping over to pick berries, their bodies forming perfect circles that match the shape of their parka ruffs, or sitting flat-bottomed on the Arctic ice, patiently drawing bullheads through a hole in the ice, they are rooted in the artist's experience, etched into her memory.

However foreign or complex the subject—a reindeer round-up on Nunivak Island, butchering a whale in Gambell on Saint Lawrence Island, drying salmon in an Indian fish camp—Rie's paintings sparkle with the authority of someone who's been there, sketchbook in hand, asked questions, and listened to the answers. An intrepid and tireless reporter, she has driven every mile of highway in Alaska, lived on a fish packer in Icy Strait, and braved the Bering Sea in a walrus-skin boat.

Early in her career, when she was employed full time as a curator at the Alaska State Museum and painting was her second job, the trips were infrequent. Now, the days when we see Rie and Buddy-Pierre bounding up and down Juneau's wooden staircases are increasingly rare. She's out in Angoon, or Egegik, or Tenakee...collecting experiences, charging her memory cells, filling her sketchbook with weird, postage-stamp-size hieroglyphics only a mother could love. A month or year or decade hence, they will coalesce and metamorphose, like colorful butterflies, into the magical images of Rie Muñoz.

Of the 99 paintings, serigraphs, tapestries, and other works reproduced in this volume, all but two pertain to Alaska, which has been Rie's home since 1950. While the selection includes her very first color reproduction, "Eskimo Story Teller," 1973 (pg. 53) as well as her most recent, "First Snow, Tenakee," 1987 (pg 40) the majority of the works date from the period 1980 to 1987. Missing among the examples of the many media she has utilized are the nine murals painted between 1951 and 1971. Ranging in subject from "Teenage Lifestyles in Alaska" to "History of Churches in Alaska," they indicate Rie's early commitment to documenting the Alaskan scene.

As I look through this tremendous collection, a smorgasbord of color and life, I am reminded of the countless occasions Rie has declined an invitation to go berry-picking, or hiking, or some other pleasurable activity because she had to paint.

Thank you, Rie, for all the times you stayed home in order to prepare this marvelous Alaskan feast.

—*Sarah Eppenbach*

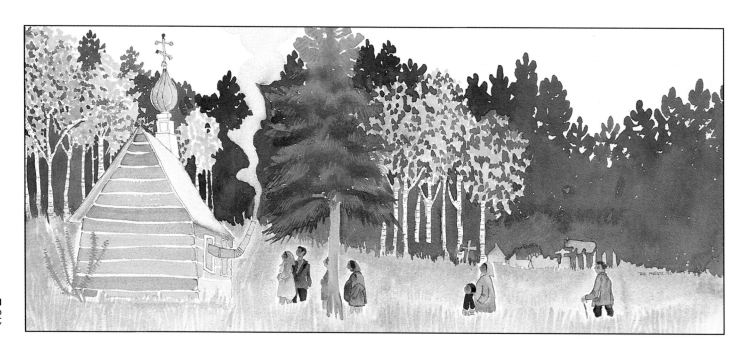

Divine Liturgy, Eklutna
1972
22" X 9½"

Originals

Originals

Rie Muñoz and Alaska are inseparable. Her style, like her subjects, is colorful, carefree, unpretentious, and full of life. Before she moved to Alaska from California in 1950, Muñoz worked in oils in a conventional, representational style. Shortly after she arrived in Juneau, a local artist encouraged Muñoz to try watercolor. She soon developed a free and easy style and found the focus of her art: the people of Alaska.

"Working with watercolors on paper, rather than with oil on canvas, I wasn't so stiff, it made me feel that I did not have to be 'serious.' I could relax and truly enjoy what I was doing. For the first time I was actually having fun painting," the artist says.

As can be seen in the works that follow, spanning the years from 1957 to 1986, Muñoz's style has remained remarkably consistent. "I haven't wandered much, but I have simplified," she

explains. "My trees for instance: in early paintings I painstakingly painted every branch. Now my evergreens are in the shape of simple cones, as in *Coming Down Mt. Roberts Trail* (page 23), that serve to complement rather than distract from the subject."

Muñoz's studio occupies the top floor of a small, two-story house located high on a hill above Juneau. The large bay window in her studio provides plenty of light and a magnificent view of Juneau, Gastineau Channel, and the peaks of Douglas Island. Immediately behind the house is the slope of a steep mountain, the far side of which abuts an immense ice field that extends beyond the Canadian border. Yet by descending a staircase of 182 steps (see *Self-Portrait,* page 28), Muñoz can be in the heart of downtown Juneau in minutes.

While Muñoz finds much to paint in and around Juneau, the majority of her material comes from visits to far-flung corners of Alaska. These sketching expeditions to the bush are often motivated by people who write and describe their communities as "Rie Muñoz paintings waiting to be painted."

Change has come to Alaska, faster in recent years than ever before. While some people still participate in traditional activities, dog teams have been replaced by snowmobiles, mukluks by Sears & Roebuck rubber boots, and fur parkas by down-filled jackets. Muñoz's recent paintings reflect these changes.

Her aim is always to capture a village "the way it is today."

A stranger visiting a remote Alaskan village, armed with pen and sketch pad, rapidly taking notes, does well to establish her credentials quickly. "Almost as soon as I start sketching, an 'unofficial investigating party', usually ranging in age from three to six, comes up to me demanding to know what I am doing," Muñoz explains. "They look at my sketches and figure I'm O.K. Then I make quick sketches of the kids and print their names in large letters under the drawings. They show these to their parents, and the villagers realize I'm harmless.

"Knowing that I'll probably not return to the village a second time, I sketch everything in sight," Muñoz says. Everything in sight includes washing pails, oil drums, nearly every dog in the village, laundry hanging to dry, local plants, birds, boats, and always people, people going about their daily activities.

When someone invites her inside for tea, Muñoz might ask to sketch the host's ancient oil stove. Once started, she'll sketch the pots and pans, boots drying under the stove, mittens hanging to dry on a line, and, should her host go over to the stove to stir a pot, he too appears in her sketchbook. When she returns home from trips to such remote locations as St. Lawrence Island in the Bering Sea, Muñoz brings with her hundreds of sketches. Disjointed as they

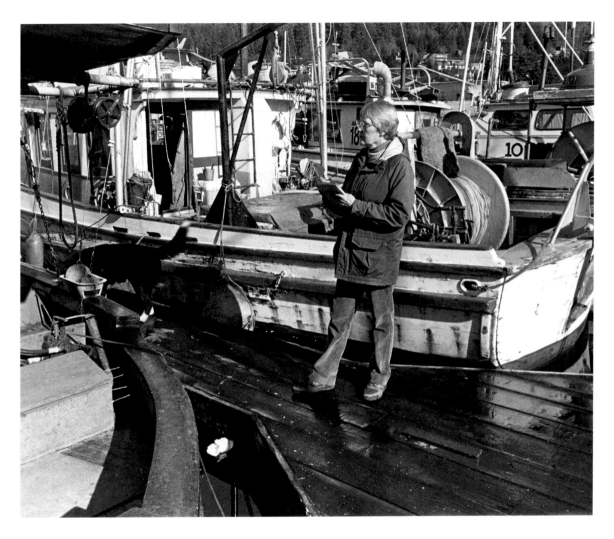

Muñoz sketching at Harris Harbor, Juneau, Alaska

may appear, these images are eventually woven into her paintings.

Like many artists, Muñoz has struggled with painting methods, and doesn't accept all aspects of traditional watercolor technique. She uses thick 300# Arches watercolor paper, but doesn't wet and tape it down, although she sometimes paints a wash over large areas of the paper.

After choosing her subject, Muñoz may do a half-dozen or more thumbnail pencil sketches to establish a composition. When satisfied, she projects the sketch with an opaque viewer onto watercolor paper and very lightly traces the image. "Sketching directly on watercolor paper to establish the composition would result in many erasures, which is very damaging to the paper," the artist explains.

Muñoz starts a work by painting the main subject, which is usually one or more figures. The completed figures act as an anchor for the rest of the painting and suggest subsequent complementary colors. For most of her paintings Muñoz uses Winsor-Newton brushes, series 233, ranging in size from 6 to 8.

Although she takes detailed color notes in the field, Muñoz invariably ignores them. More often than she likes, Muñoz looks at a partially finished painting and realizes "the composition doesn't work. The colors are all wrong." She reverses the sheet and immediately starts over again. Usually she is happy with the second attempt.

Other times, Muñoz reaches a point where she does not know how to continue. Rather than going on, hoping the painting will work out, she puts it aside to work on an entirely different subject. By not looking at the work or even thinking about it, she can pick it up again, days or months later, and clearly see what the next move should be. A painting that moves along without a hitch usually takes the artist two days to a week to complete, depending on its size and complexity.

Painting a myth or biblical work takes Muñoz considerably longer. Because she has no sketches, no vivid impressions, she tries to create a strong mental image before attempting it on paper. " *Ark in Alaska* bounced around in my head for two years and still it was nothing more than a blurry vision," she says, exasperated by the memory. Finally, not yet ready to give it up, Muñoz started working with thumbnail sketches. Her efforts, illustrated on page 62, are only four of twenty to thirty attempts.

When Muñoz puts her brushes aside for a sketching expedition or for a trip to Europe to make a serigraph, she returns to find the act of painting a seemingly hopeless endeavor. Painting after painting fails. "I simply lose my touch," she admits. Years ago when this happened she would become frustrated and terribly depressed, ready to give up painting altogether. She has long since learned that by constant effort, throwing away "disaster after disaster," she will eventually, in a week or so, work herself back into top form. Continuing to paint daily keeps her efforts productive.

Muñoz tries to paint at least four hours a day, but because of many interruptions, she often falls short of her goal. To make up for lost time, or if she has a solo-show deadline to meet, she'll take the phone off the hook and paint eight hours a day, taking a break to eat a sandwich or take her dog for a quick walk part way up the mountain trail.

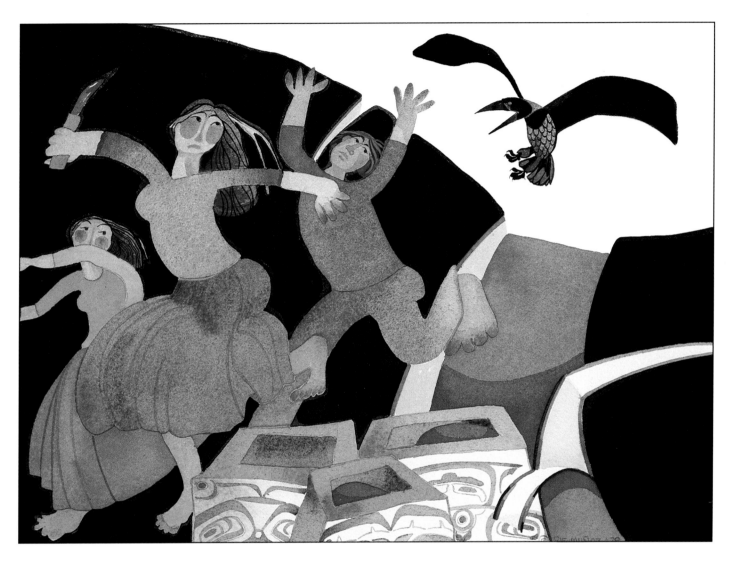

Raven and Whale
1978
15" X 11¼"

"*Raven and Whale* is from a Haida legend, as told by Frances L. Paul in her book, **Kahtahah**, which I illustrated. I have illustrated a few books, but have called it quits. I like to paint scenes that *I* like to paint. Illustrating a book is painting scenes that someone else likes me to paint."

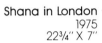

Shana in London
1975
22¾" X 7"

"My neighbor Shana is now a beautiful young woman. How well we both remember when she was eight years old and I took her on a trip to London."

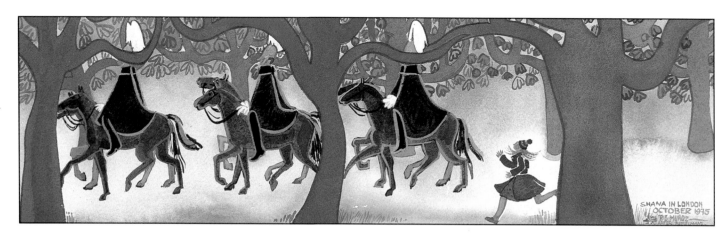

The Pied Piper of South Franklin
1969
40" X 14"

"Pied Piper of South Franklin hangs in a Juneau veterinary clinic. All the dogs are real Juneau dogs from that time. The vet tells me that people always comment on the painting, exclaiming "Oh, there's my dog!" or, "Oh, where's my dog?"

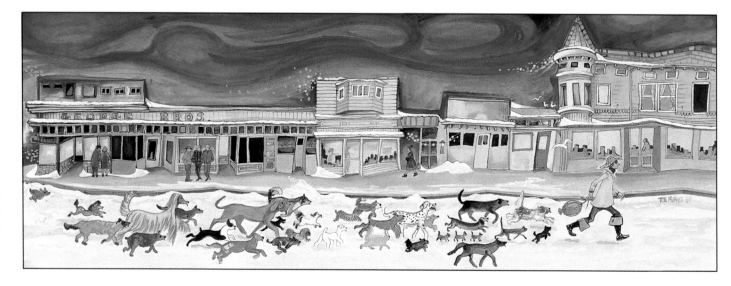

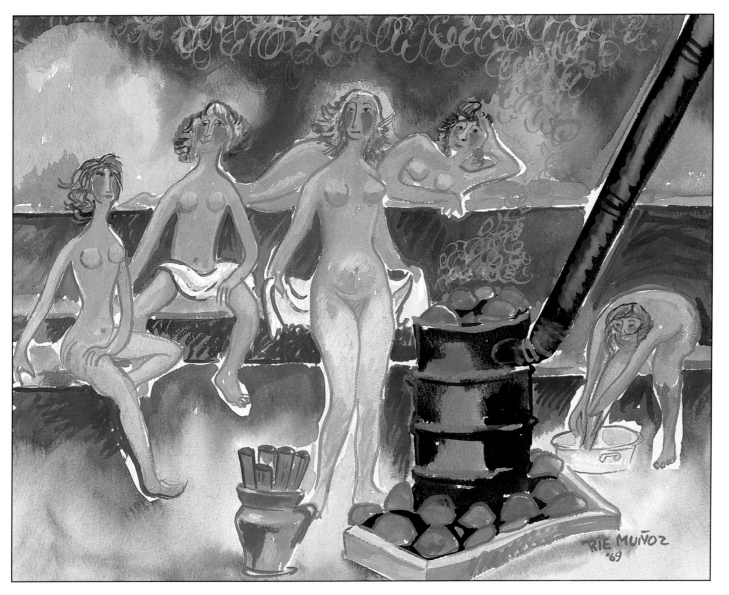

Sauna
1969
12½" X 9½"

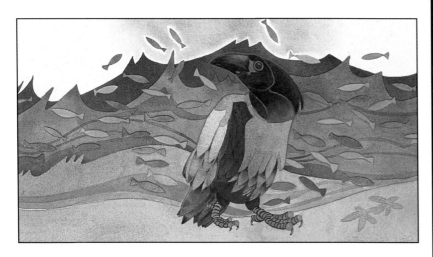

Raven and Herring
1980
15⅜″ X 8¼″

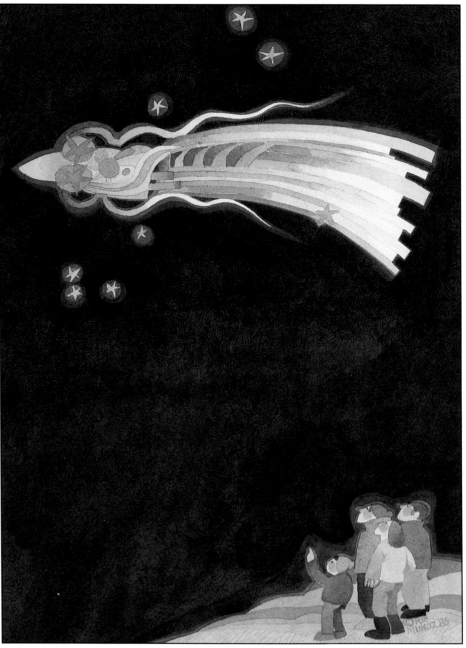

Halley's Comet Sighted
1986
8¾″ X 10″

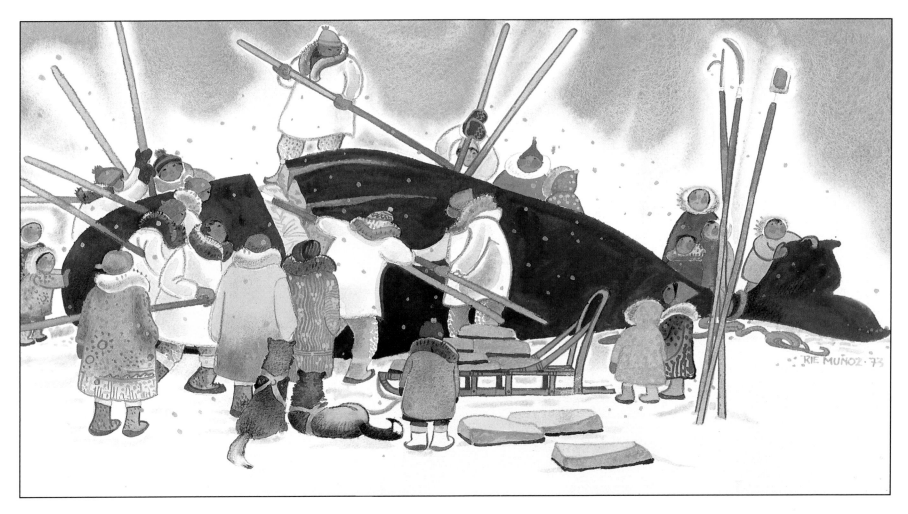

Butchering A Whale, Gambell
1973
22½" X 10½"

"The villagers of Gambell, an Eskimo village located on St. Lawrence Island in the Bering Sea, depend on an annual harvest of bowhead whales. Butchering a whale is a community project in which virtually everyone participates, and shares, equally. By the time the process is complete all that remains are the bones."

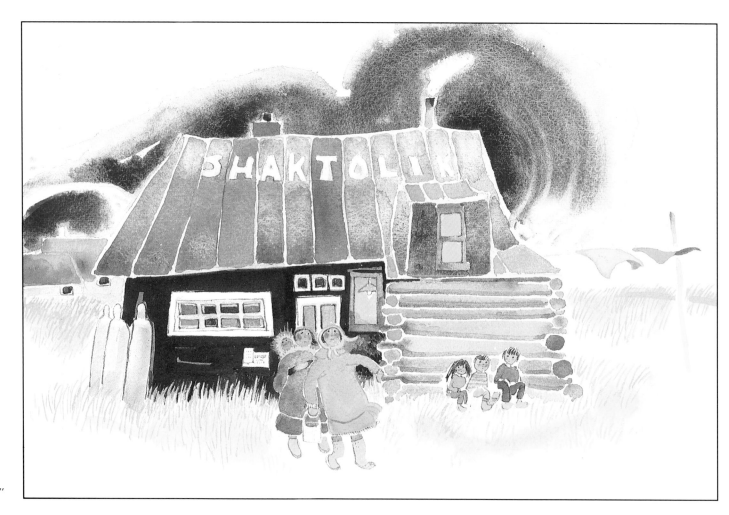

General Store,
Shaktolik
1972
13½″ X 9½″

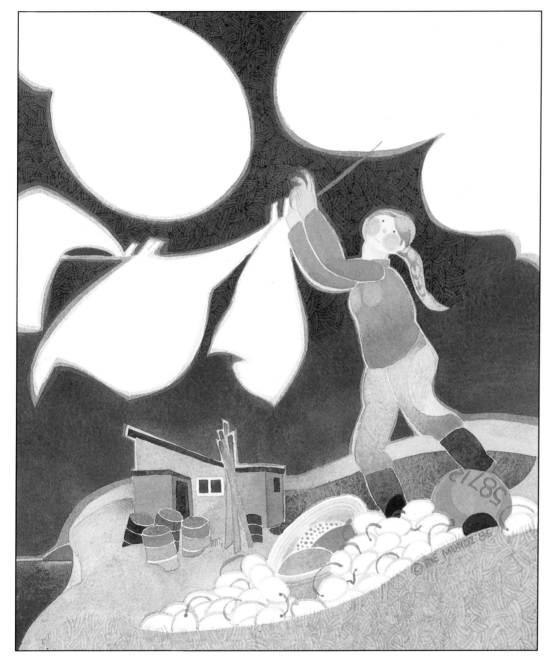

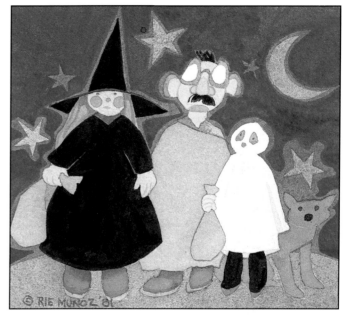

Trick or Treat
1981
4" X 4⅞"

Laundry, Egegik
1986
9¾" X 11"

"The tiny village of Egegik on the Alaska Peninsula is one of a number of places where I've been invited to paint. I went there in 1986, did about eighty sketches, and have produced several paintings so far. There are more to come. The woman, my hostess, actually had black hair, but against a dark sky that would never do."

**Ringing the Church Bell,
Nondalton**
1981
14¾" X 10"

"Ringing the Church Bell shows how ingenious village people can be. Nondalton, an Athapascan village near Lake Iliamna, has a Russian Orthodox church but no belfry. The Russian priest salvaged a prop from a plane that had crashed nearby and, using a hammer as a clapper, summons his parishioners. The prop works very well and has a wonderful tone."

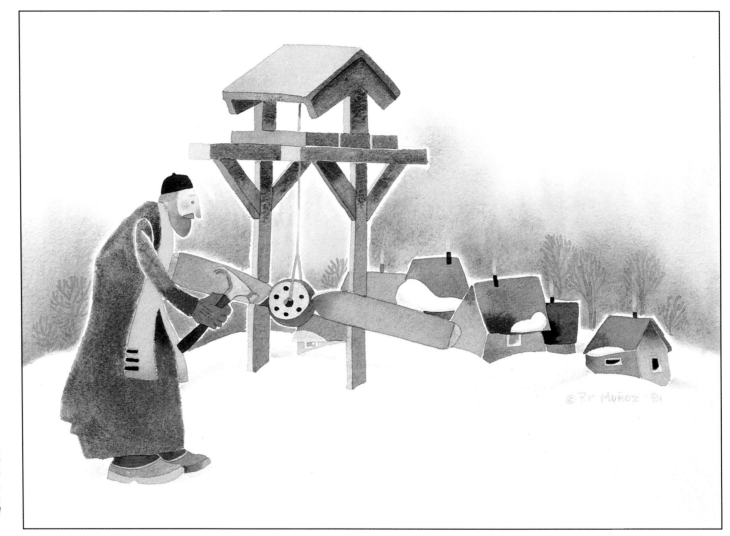

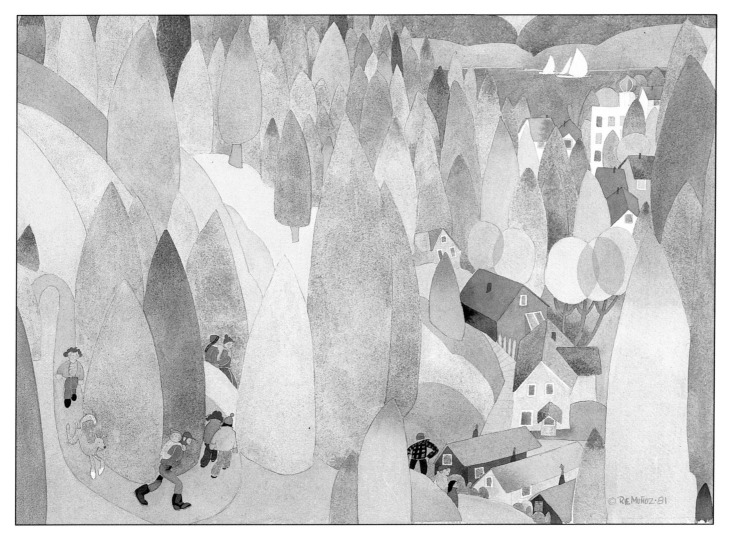

**Coming Down
Mt. Roberts Trail**
1981
24" X 16½"

"Almost directly behind my house is the Mt. Roberts trail. I climb the mountain several times a year, usually with friends and our dogs. I rarely show much depth of vision in my work, but much enjoyed my attempt in this one. I've always thought this work could be translated into a beautiful, rich Aubusson tapestry."

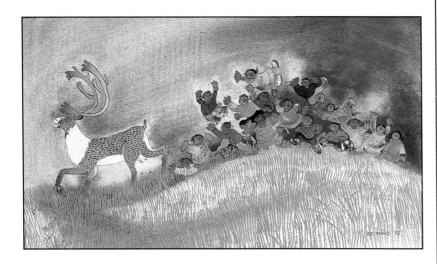

Runaway Reindeer
1973
30" X 18¼"

"Nearly all the villagers of Mekoryuk on Nunivak Island participated in the reindeer roundup. After being corralled, most of the animals were marked and then released. The children of the village would gather at the release gate and run after the reindeer as they were let go. Although the reindeer would quickly outrun the young Eskimos, they had great fun chasing the animals over the tundra. I tried to capture that feeling by showing some of the children flying through the air."

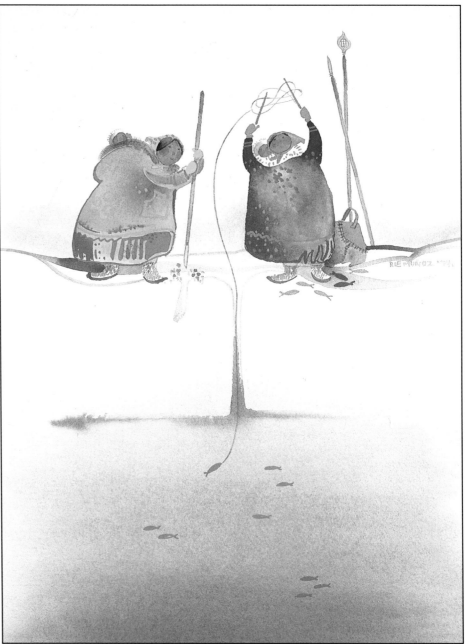

Ice Fishing
1974
11¾" X 16½"

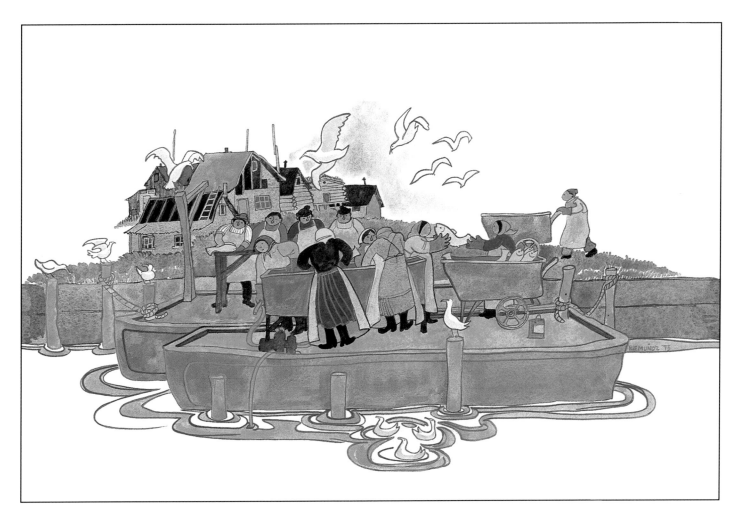

Cleaning Fish on the Kuskokwim
1973
22″ X 11¼″

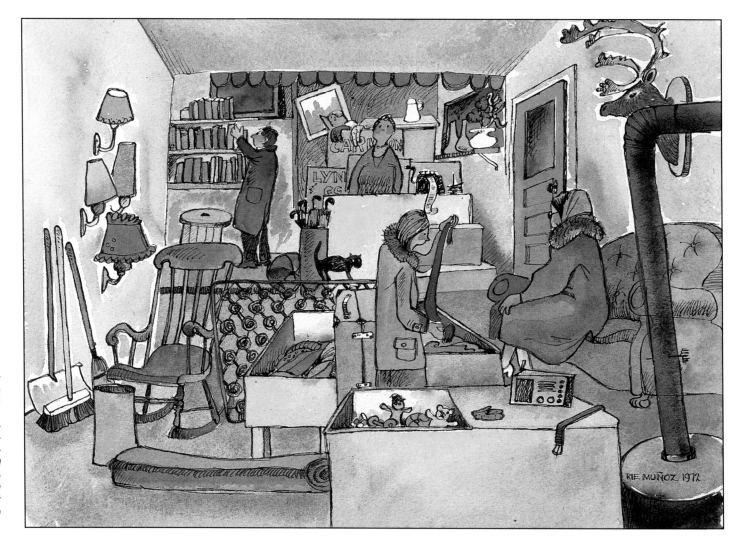

Salvation Army
1972
14" X 10"

"The cat was actually sleeping on the couch, but because the helter-skelter composition needed a focal point, I placed it in the middle of the picture. The store had a large empty area on the left in which I later painted my own rocking chair."

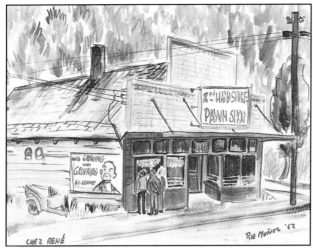

2nd Hand Store
circa 1957
24" X 18"

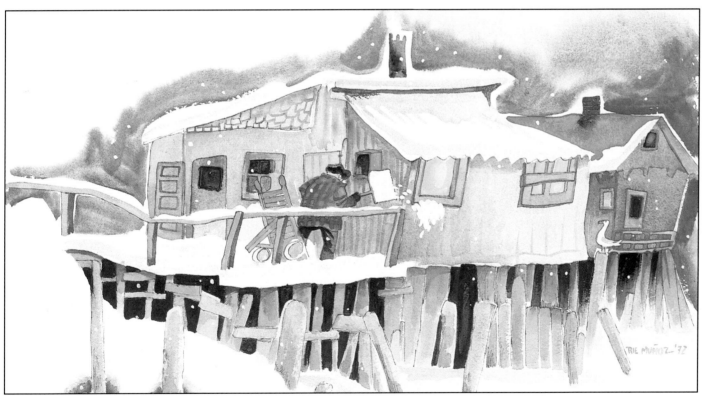

Shoveling Snow
1972
22" X 14"

"This area of Juneau, now long gone, was very colorful and fun to sketch. All the houses were built on pilings over the tideflats. It had the flavor of Southeast Alaska that can still be found in smaller outlying communities. Many years ago, in the interest of urban renewal, the structures were removed and the flats filled."

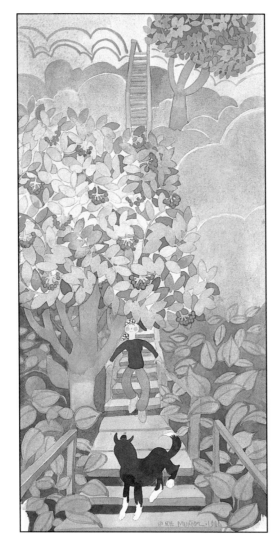

Self Portrait, 4th St. Stairs
1981
6¾" X 14"

"This stairway, one of many in Juneau, leads from my house on Starr Hill to downtown. One hundred eighty-two steps! I go up and down these stairs almost every day. A great way to keep in shape, for me and my dog, Buddy-Pierre, too!"

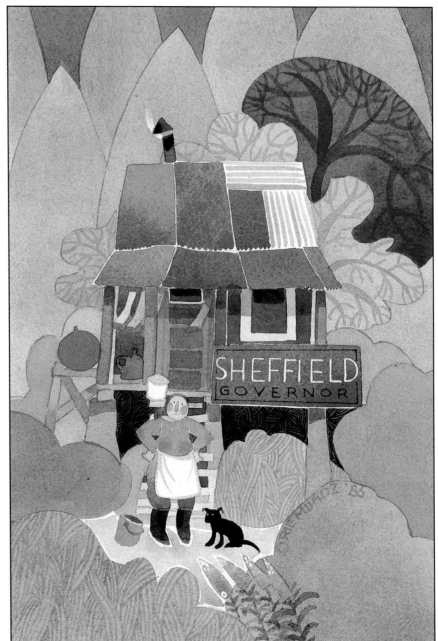

A Vote For Sheffield
1986
7½" X 10"

Reproductions

Reproductions

Of the sixty to eighty watercolors Rie Muñoz produces a year, a dozen or so are chosen for limited-edition reproductions. Limited-edition prints, as well as posters, are reproduced from original watercolors by the offset lithograph printing process. The majority of the reproductions shown here were printed at Ultracolor in El Segundo, California.

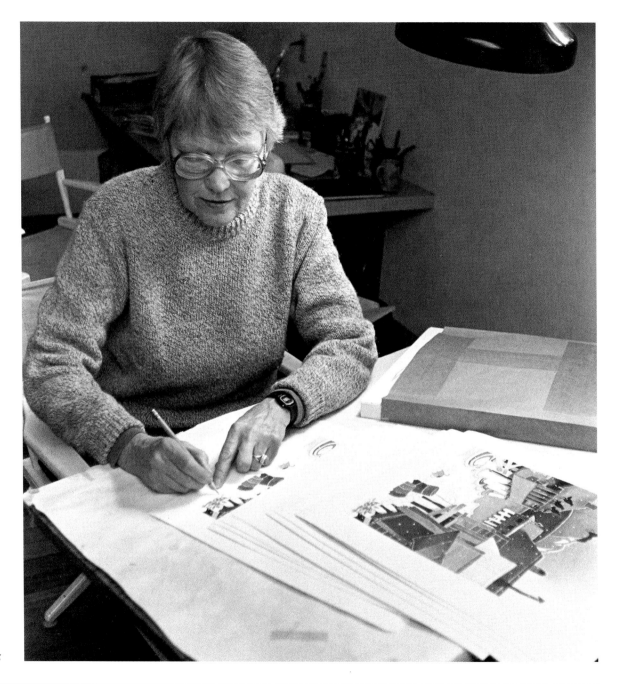

Rie Muñoz

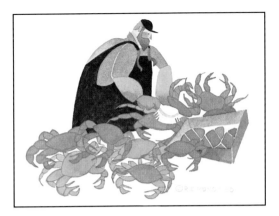

Packing Dungeness
1986
5¼" X 7"

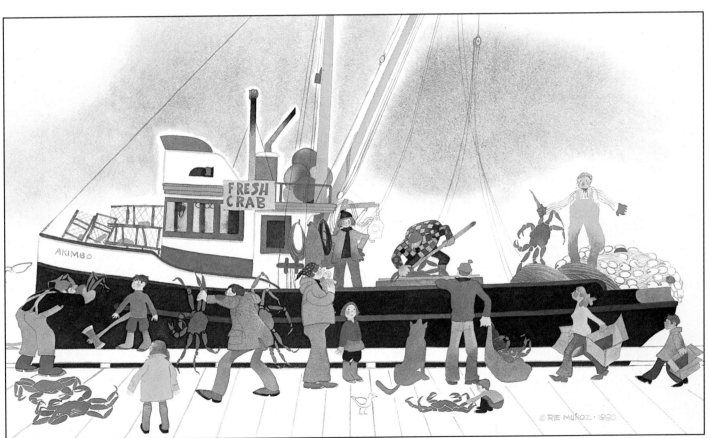

Douglas Crab Boat
1980
25½" X 14½"

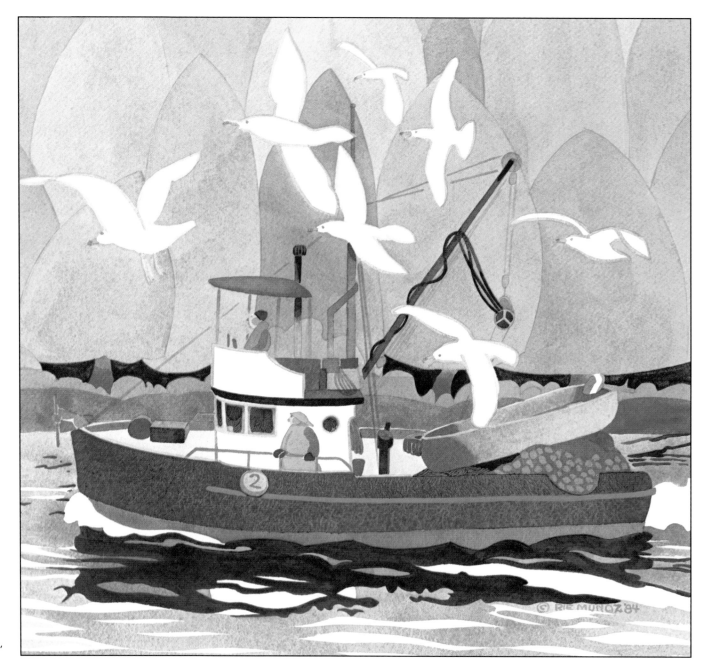

Coming Home
1984
13″ X 12″

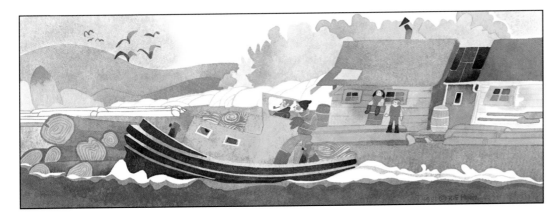

Boom Boat
1981
7½" X 20½"

Steam Bath
1984
9¾" X 7½"

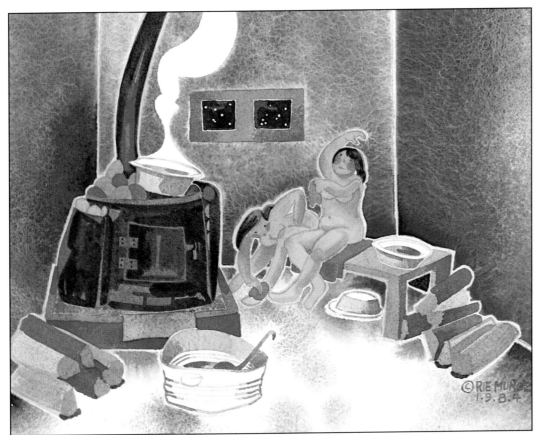

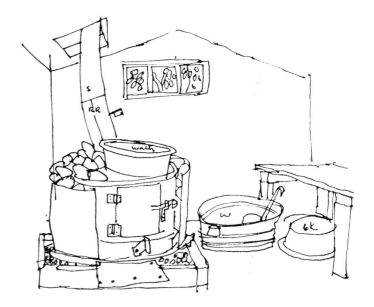

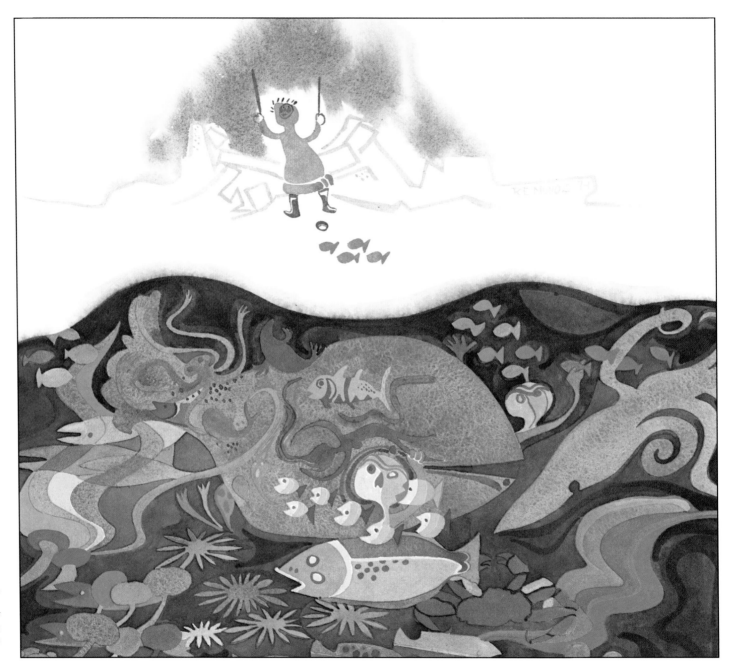

Scary Sea
1974
17" X 16"

"This imaginary scene was inspired by my stay on King Island, where I taught school in 1951-52. It was painted twenty-two years later. People along the Bering Sea coast partially subsist on ice fishing. Whenever I looked down one of those pitch black fishing holes I imagined the worst–and here it is."

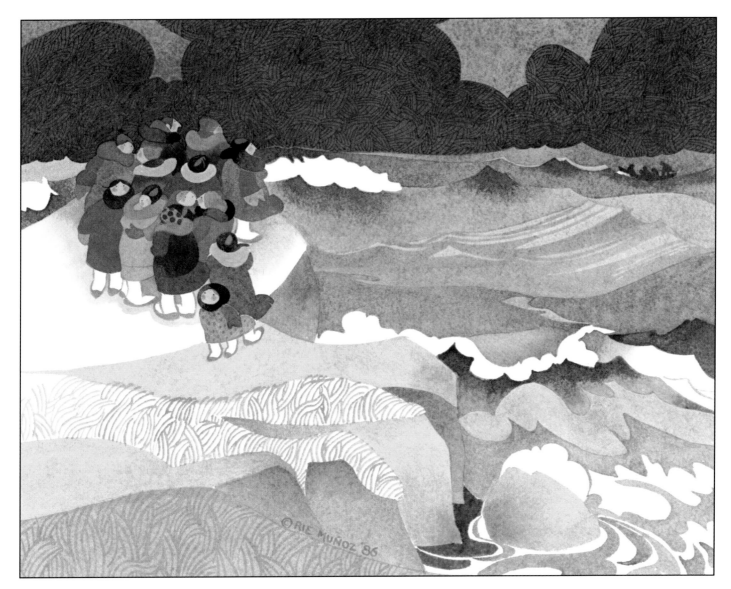

Late Boat
1986
12⅞" X 9⅜"

"Waiting for a late hunting party to come home can be very tense. When darkness comes lanterns are brought out to mark the way home."

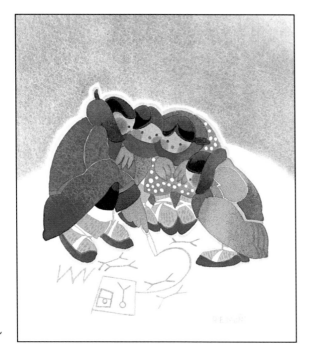

Story Knife
1985
7" X 8"

The Last Caribou
1979
9⅝" X 13⅝"

"Although this painting appears to be a legend, it was inspired by a story told to a government caribou census agent by a Nunivak Island Eskimo at the turn of the century. The Eskimo explained there were no more caribou since about 1850 when the Eskimos had followed the tracks of the last caribou to the point where the tracks ended and the caribou had disappeared into the sky."

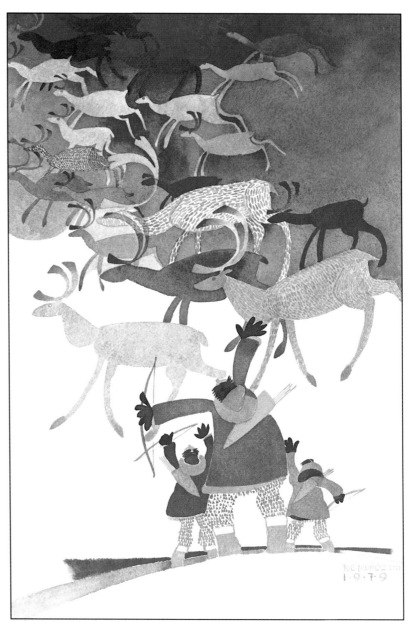

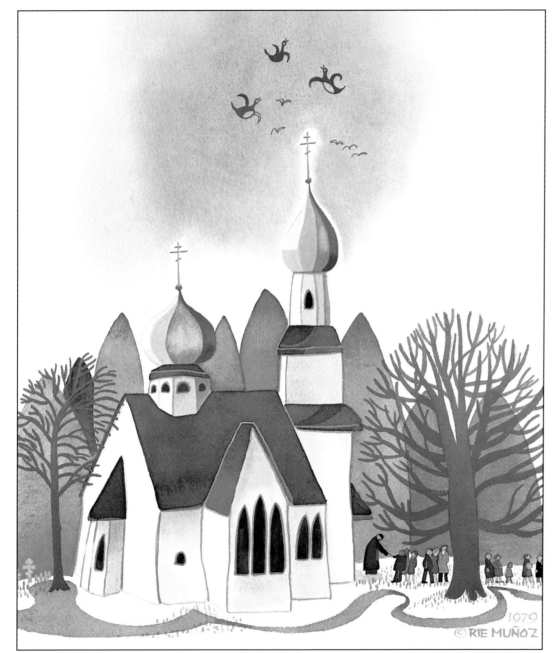

Russian Church, Kodiak
1979
13¾" X 16"

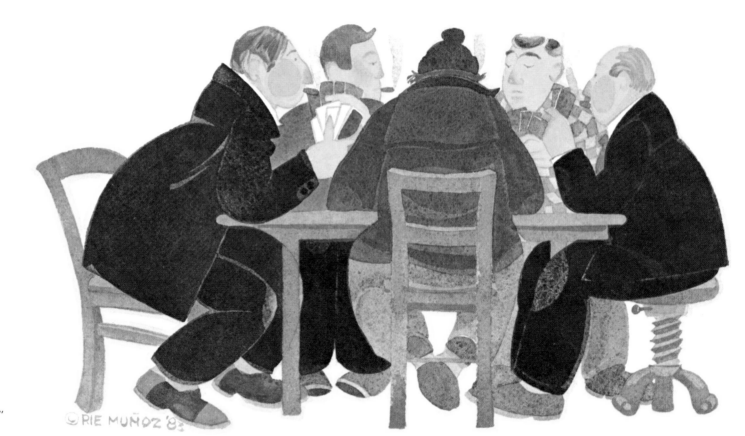

Poker Game
1983
9" X 5¼"

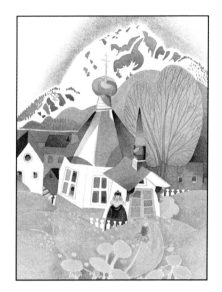

Spring Sunday
1985
9" X 12"

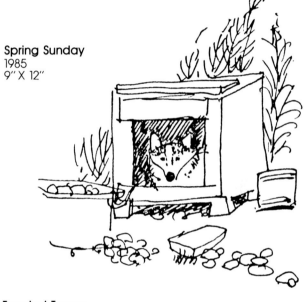

Tangled Traces
1984
8¾" X 5½"

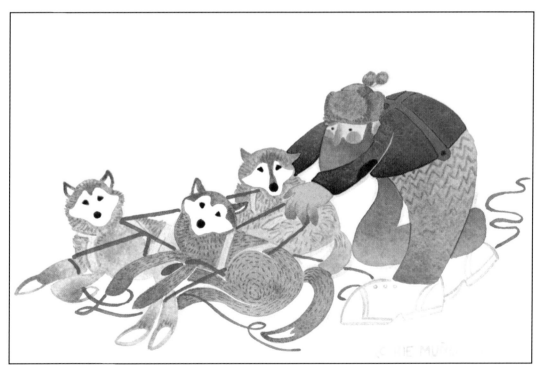

"In modern-day Alaska, sled dogs are used almost exclusively for racing. The Iditarod Sled Dog Race is the longest and most popular in Alaska. One winter, at the Iditarod checkpoint in Shaktoolik, I saw this scene, a typical problem during the race."

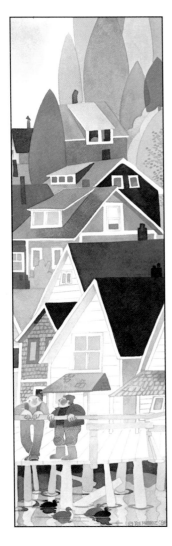

Hopkins Alley
1981
6¼" X 21¾"

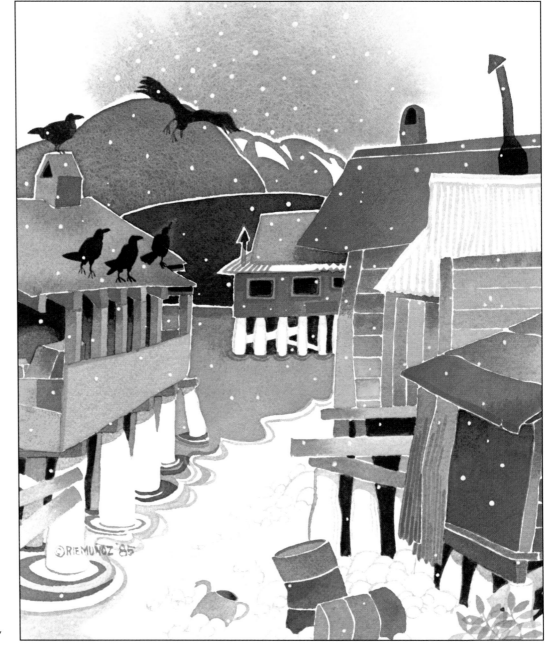

First Snow, Tenakee
1987
10" X 11¾"

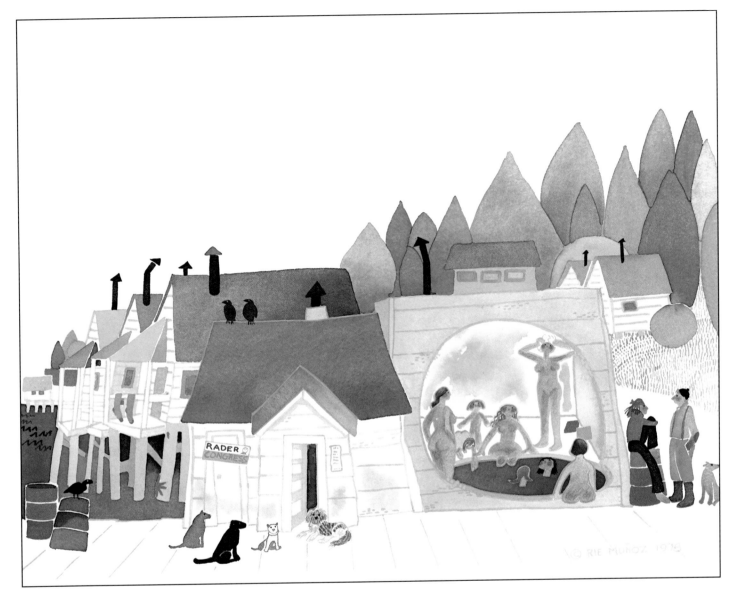

Ladies in the Bath, Tenakee
1978
18" X 11"

"One can always tell who is inside the mineral hot springs at Tenakee by the dogs sitting outside. Two men casually talking outside the bath indicate to the viewer that the circular window is only a figment of my imagination."

42

Winter Sun, Gambell
1977
12⅜" X 17½"

*"I painted **Winter Sun, Gambell** for the extraordinary, flattened sun, with vivid shafts of light shooting above and below, seen while on St. Lawrence Island. A scene like this has to be exaggerated to give impact."*

Groceries, Nome
1984
8⅜" X 11"

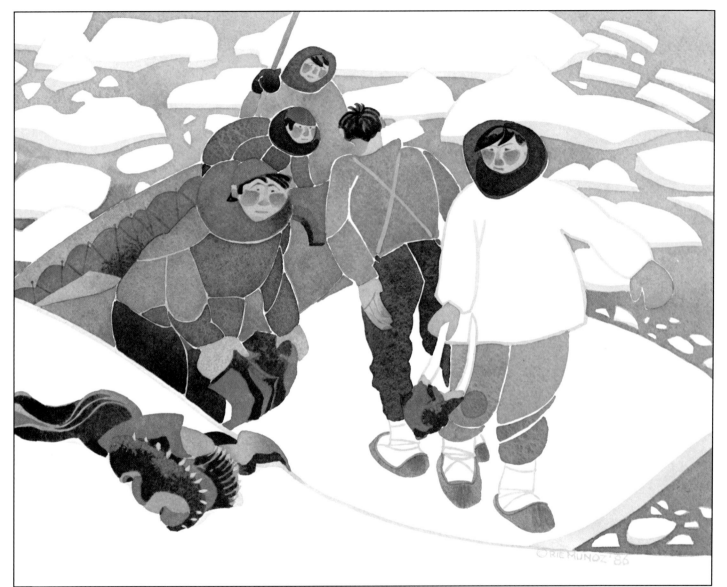

Unloading Walrus Meat
1986
13¾" X 10¾"

"Unloading Walrus Meat was sketched in the month of May on St. Lawrence Island in the Bering Sea. It was still bitterly cold and I could only sketch for about two minutes before I had to put my mittens back on to warm up. Sketching conditions are rarely ideal in Alaska. If it isn't icy cold, it's raining or a strong wind is blowing. If the air is calm, the mosquitos come out in droves."

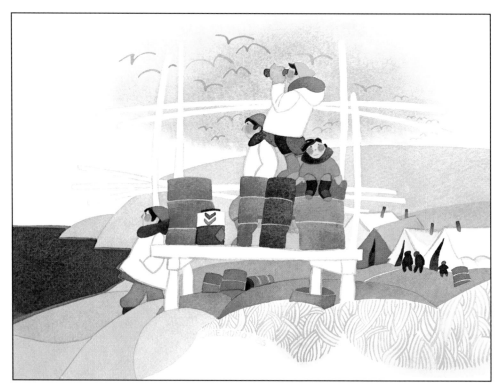

Looking For Belugas
1986
11¾″ X 9″

"Belugas are small white whales that travel in groups, or 'pods.' They are hunted in Kotzebue Sound during early summer. I spent a week sketching at a whaling camp on the shore of the sound."

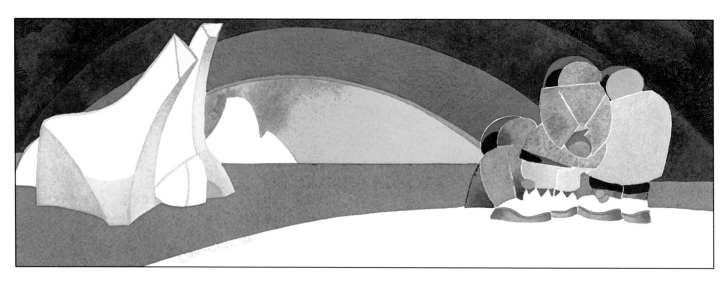

Whale Watch
1986
14¼″ X 5⅛″

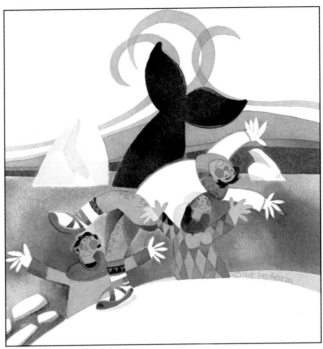

Whale!
1986
11⅞″ X 12½″

"There is great excitement in a whaling camp whenever a whale is spotted. Bowhead whale hunting occurs in spring when the ocean ice begins breaking up, opening enormous 'leads' in the ice pack."

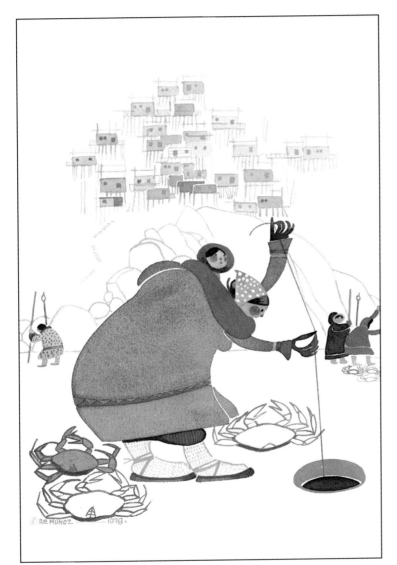

Fishing for King Crab, Ukivok
1978
11⅝″ X 14″

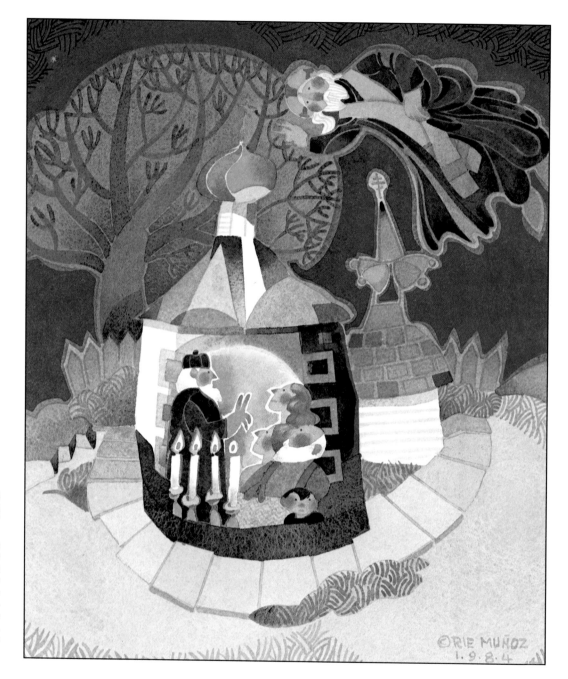

St. Nicholas
1984
9⅛" X 12"

"St. Nicholas Russian Orthodox Church is only a few blocks from my home in Juneau. I walk by it every few days and paint it frequently– in this painting with considerable artistic license. Hovering overhead, the church's namesake blesses the congregation within."

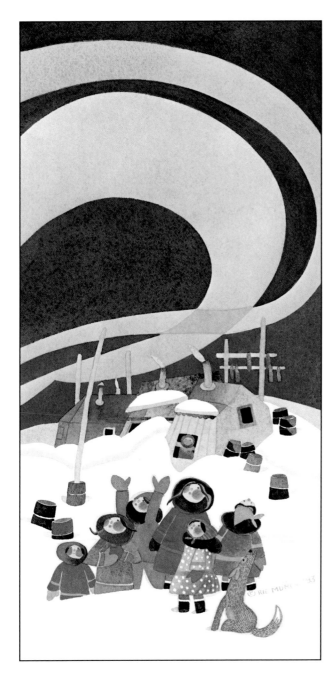

Looking For Halley's Comet
1986
6" X 10"

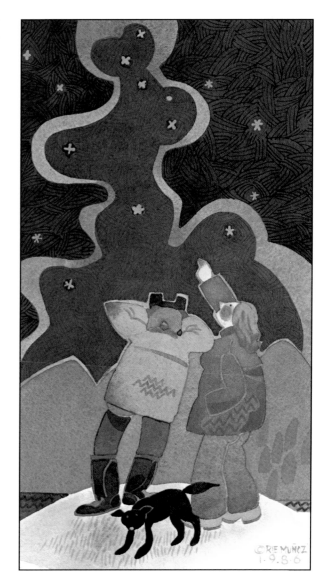

**Whistling at the
Northern Lights**
1983
6⅞" X 13½"

"*There are many good reasons why children whistle at the northern lights. In one village children say they whistle to make them go away; in another village, to make them dance. Sometimes when asked, they only giggle. I've seen children do this many times, their heads bent back, their feeble whistles barely audible.*"

48

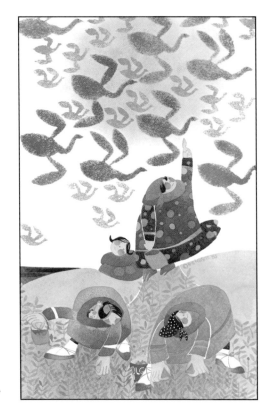

Fall Migration
1986
12¼" X 21"

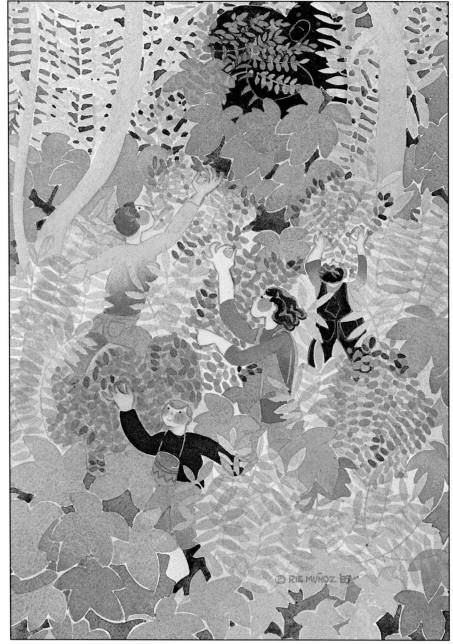

Blueberries
1985
9⅞" X 13"

"Whenever my friends and I go berry-picking at Tenakee Springs on Chichagof Island, we are always on the alert to the possibility that a bear may be eating berries on the other side of the bush. I purposely painted the bear in this scene hoping it wouldn't be seen immediately, to give the viewer the type of 'start' it might give a berry picker."

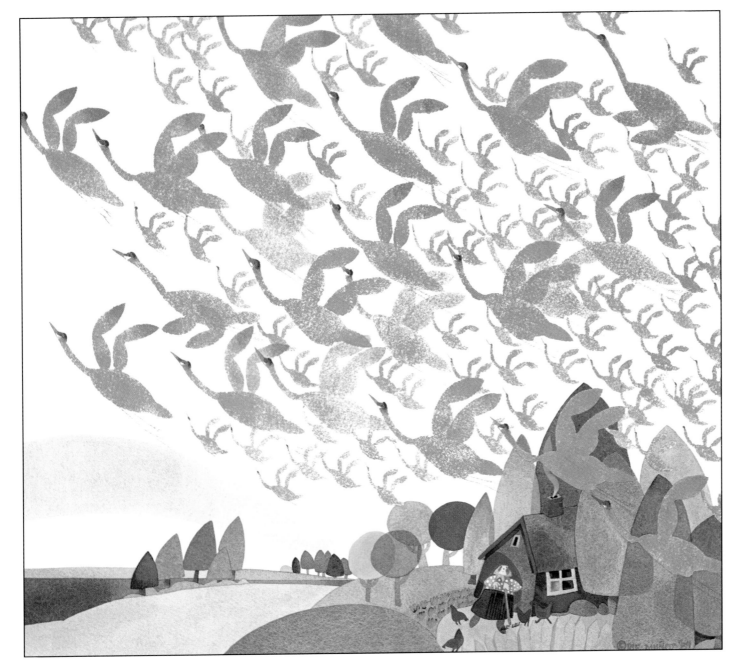

Sandhill Cranes
1984
15½" X 13½"

"For a brief period during the spring and fall waterfowl migrations, the sky above Gustavus, near Glacier Bay, comes alive with thousands of sandhill cranes that come to rest for the night. I was told that about 30,000 cranes land in fields around the community each migration."

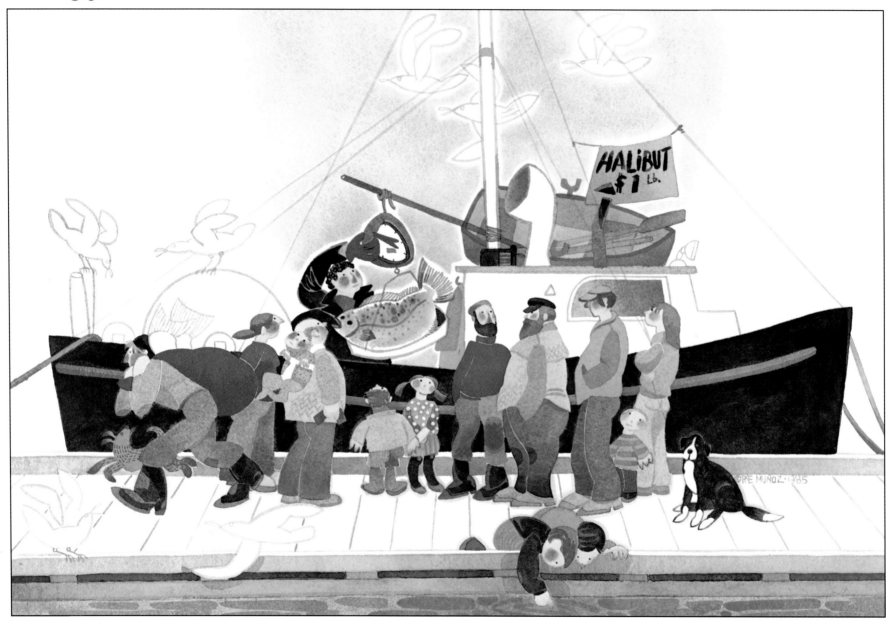

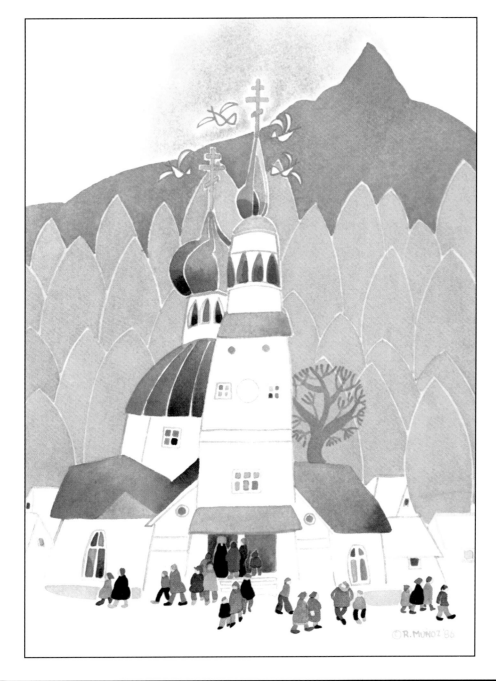

◄ **Halibut $1**
1985
17⅝" X 12"

"Following the brief com-
mercial halibut seasons, fish-
ermen often sell their catch
right off their boats at the
Juneau float. Local residents
from all walks of life take the
opportunity to stock up on a
supply of halibut at very rea-
sonable prices. I sprinted
down to the float too and
made lots of sketches, of
which this is the result."

Cathedral, Sitka
1986
9⅝" X 12¾"

In the Park, France
1983
5⅝" X 6"

"I spent the summer of 1983 painting and sketching at St. Jeannet, Southern France. **In the Park** depicts the siesta hour when some people nap and others sit quietly in the park."

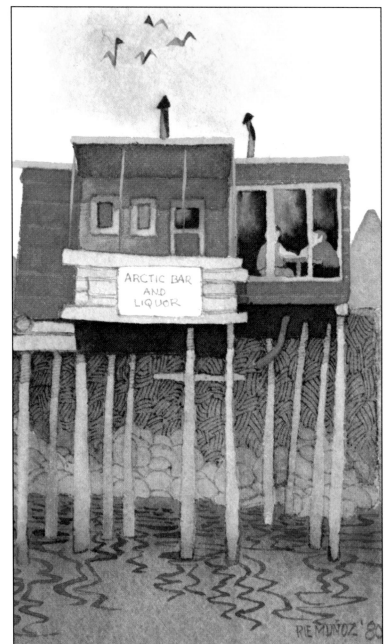

ARCTIC BAR
AND
LIQUOR

Ketchikan, Alaska
1980
3⅞" X 6¾"

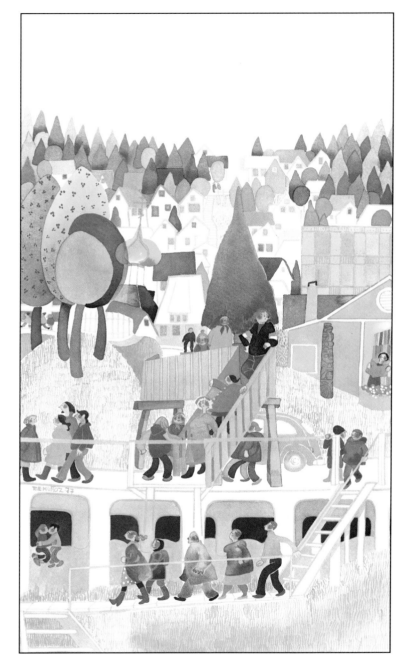

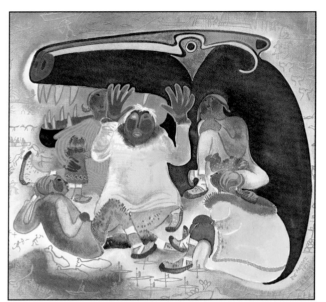

Eskimo Story Teller
1973
14½" X 13"

"Surrounding the story-teller I drew representations of markings found on ivory implements, such as knives, drills, and handles. These markings were a record of events: whales and boats sighted, animals killed, voyages undertaken, and so on. This was my first limited-edition reproduction."

Going to Work
1977
14" X 19¾"

Posters

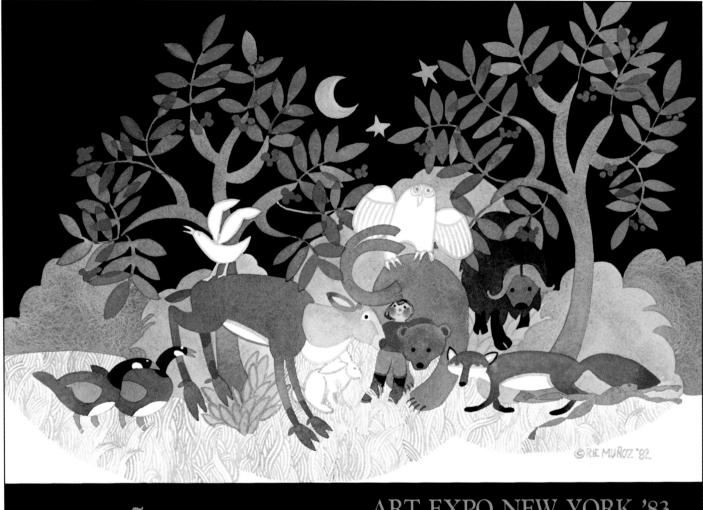

RIE MUÑOZ

ART EXPO NEW YORK '83
"Peaceable Alaska"

Peaceable Alaska
1984
24" X 18"

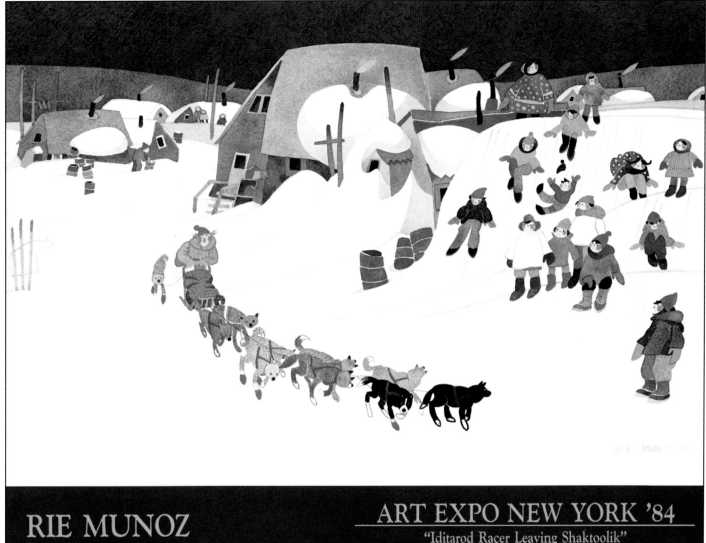

RIE MUNOZ

ART EXPO NEW YORK '84
"Iditarod Racer Leaving Shaktoolik"

Iditarod Racer Leaving
Shaktoolik
1984
24" X 18"

Sitka Summer Music Festival
1986
12¾″ X 24″

King Island Christmas
1985
18″ X 24″

*"The village of Ukivok was built on the side of an incredibly steep cliff. The houses were built on very long stilts, with the back of the houses resting on the rocks of the cliff. This is one of my illustrations from the children's book **King Island Christmas**, by Jean Rogers."*

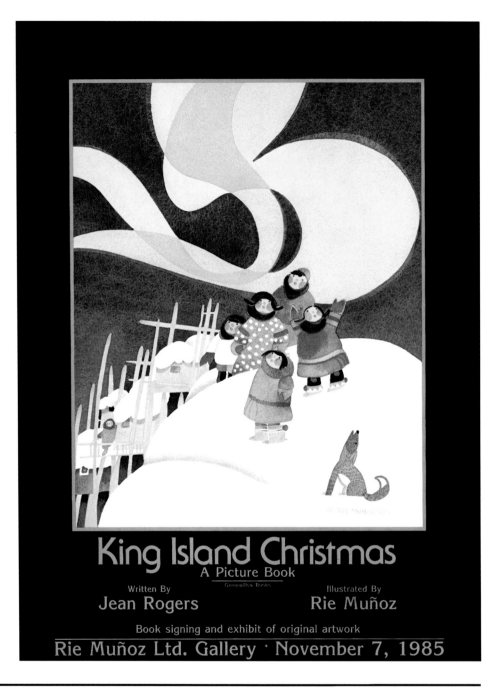

King Island Storm
(from the book **King Island Christmas,** by Jean Rogers)
1986
24″ X 18″

Whaling Camp
1983
24" X 18"

"A beluga whale has just been spotted and pandemonium breaks out. The villagers rush to the boats, taking oil, gas, floats, rifles, and outboard motors. This is another scene from the whaling camp at Sigik."

Pushing Home Through Baby Ice
(poster from a tapestry)
1982
24" X 18"

"Baby Ice was made into a tapestry in Aubusson, France. 'Baby ice' is a literal interpretation of an Eskimo word that describes a type of spring ice that is very, very treacherous. If the men are out hunting and the wind shifts towards shore, the ice is too thin to drag their umiaks across and yet too compact to push their way through. In this scene the men are trying to get home while the villagers watch with great concern."

Serigraphs and Stone Lithographs

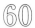

Serigraphs and Stone Lithographs

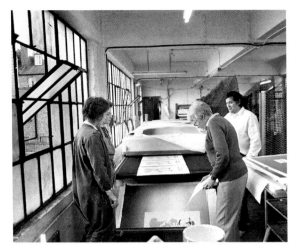

(Left) Muñoz reviewing prints as they come out of the serigraph print dryer, Coriander Studios, London, England.

*(Below) Stencils for **Throat Chanters** serigraph*

Producing original serigraphs (silk-screen prints) and stone lithographs is a collaborative effort in which Rie Muñoz works closely with master printers to achieve the best possible results.

Muñoz starts with a rough idea, refining it to a working sketch. In the case of a serigraph, the artist cuts stencils (one for each color). The master printer then prepares the stencils for screening. In stone lithography, the sketch is translated by Muñoz onto the stone, which is then prepared for printing by the lithographer.

In each case the artist and printer work together on color proofing. When the desired colors are established the master printer hand-pulls the edition.

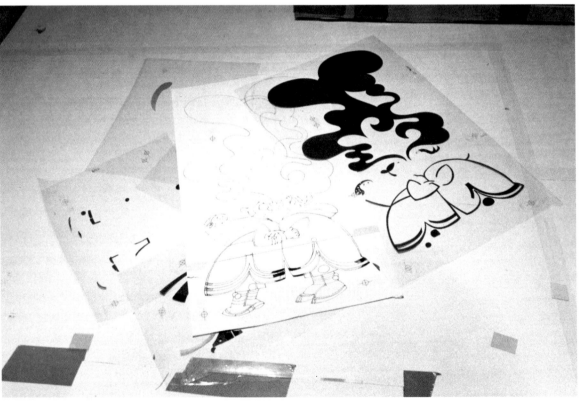

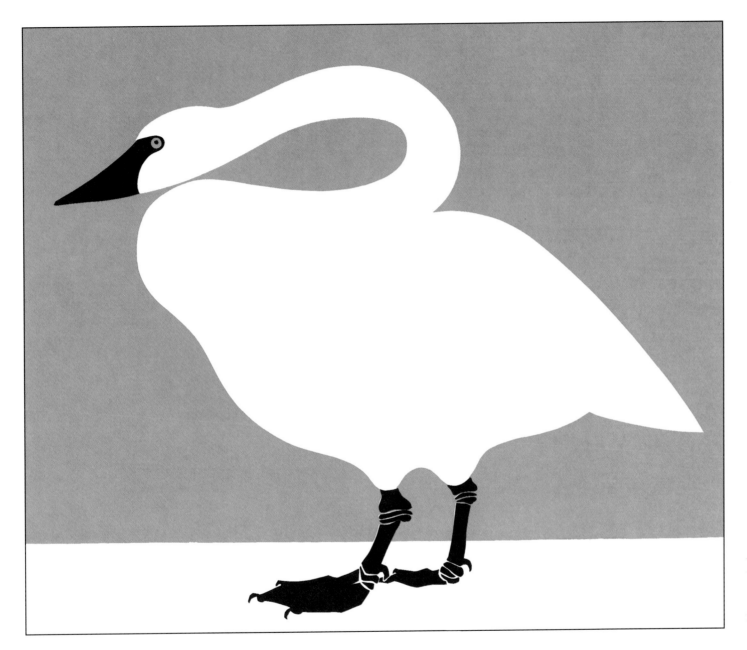

Trumpeter
1976
Serigraph
Printer: J. Crondahl
Juneau, Alaska
18" X 15"

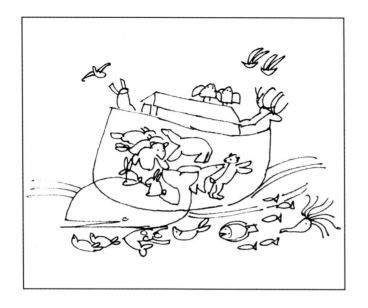

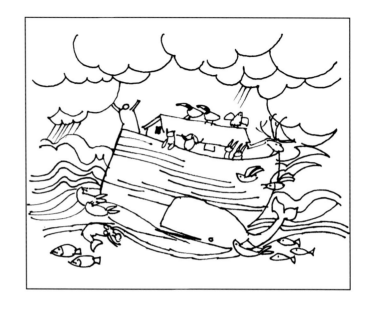

Ark In Alaska

"I first tried to do this as a painting, then I tried it as a serigraph. The pencil drawings helped me to simplify the image. With the possible exception of the mermaid, all of the animals are found in Alaska."

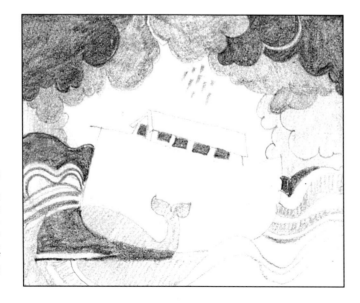

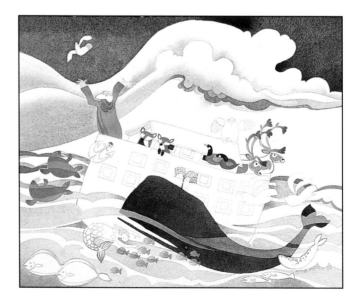

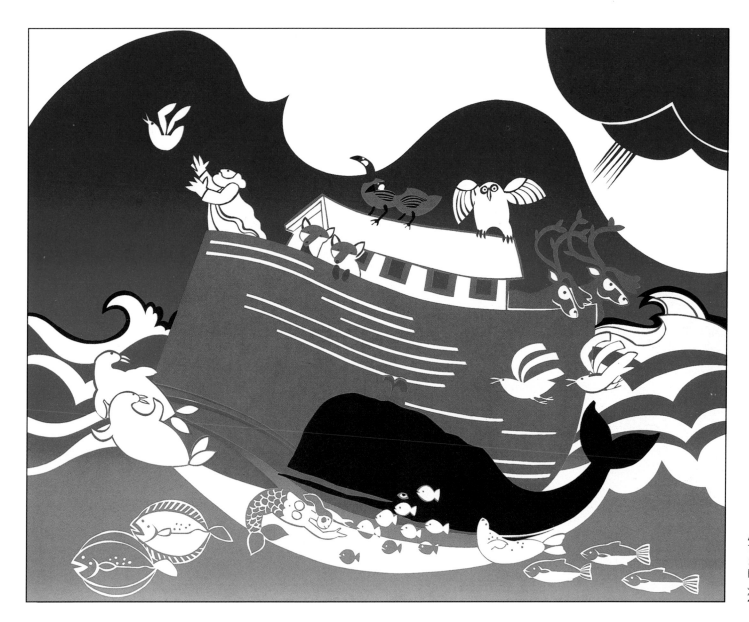

Ark In Alaska
1985
Serigraph
Printer: Halibut Fine Arts
Juneau, Alaska
20" X 16"

Raven Legend
1981
Serigraph
Printer: Prints and Panels
Juneau, Alaska
20½" X 11¾"

Raven fished every day and stored the salmon in a cache. Raven had an accident and died. All winter his two mourning wives lived on the stored fish. When it was gone they wondered how they would survive. They solved the problem by turning back into ravens again. (Athapascan legend.)

Raven Had Two Wives
1979
Serigraph
Printer: Prints and Panels
Juneau, Alaska
17⅝" X 11⅛"

"One legend inspired both images (pages 64 and 65)."

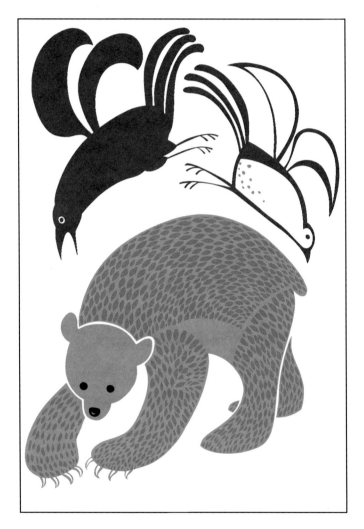

Fish Grader
1980
Serigraph
Printer: Prints and Panels
Juneau, Alaska
10" X 18"

Raven Went Bear Hunting
1980
Serigraph
Printer: Prints and Panels
Juneau, Alaska
12½" X 18"

"Raven is a recurring figure in many legends of the Native peoples of Alaska. This is from an Athapascan legend in which Raven enlists other birds in his efforts to kill a bear. In a most mischievous way, Raven achieves his purpose."

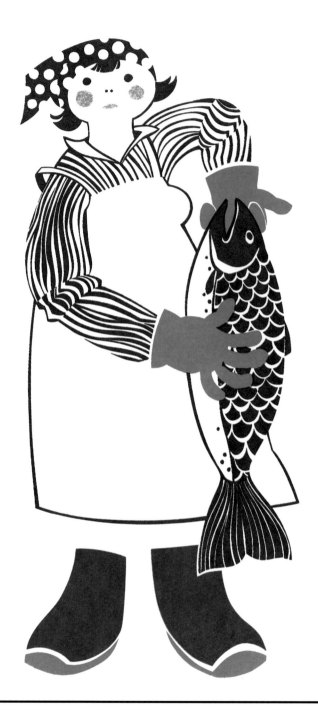

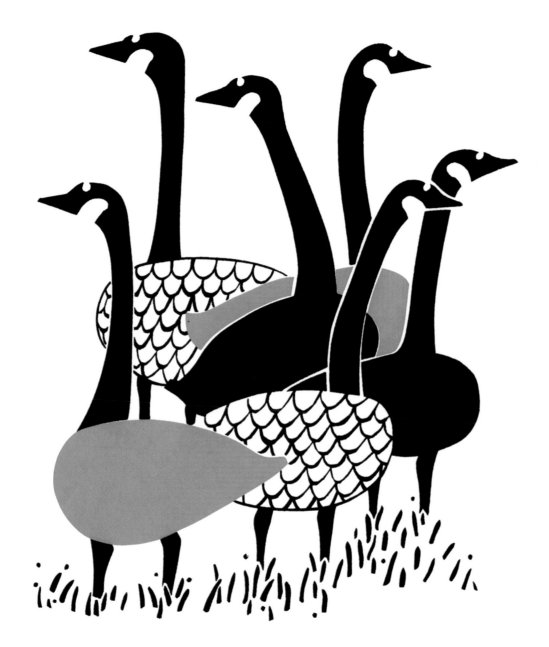

Gold!
1979
Serigraph
Printer: Prints and Panels
Juneau, Alaska
20" X 14"

"During Juneau's centennial celebration in 1980, I was commissioned by the city to do a historical scene. This depicts the moment Joe Juneau and Richard Harris discovered gold in 1880."

Honkers
1975
Serigraph
Printer: J. Crondahl
Juneau, Alaska
11" X 12"

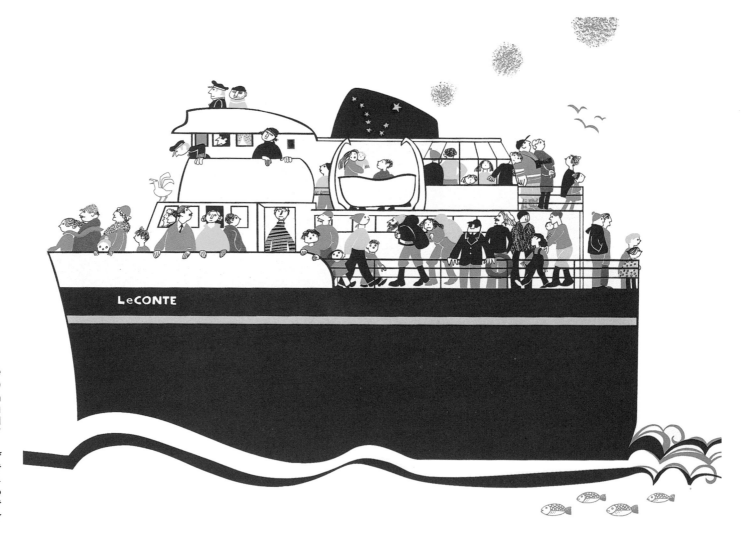

Summer Voyage
1980
Serigraph
Printer: Megara
London, England
22¼" X 15½"

"To get the full flavor of Southeast Alaska, one must travel by ferry. The smaller ferries in the fleet, such as the **Le Conte**, *serve the villages. Most of the ferries are named after Alaskan glaciers."*

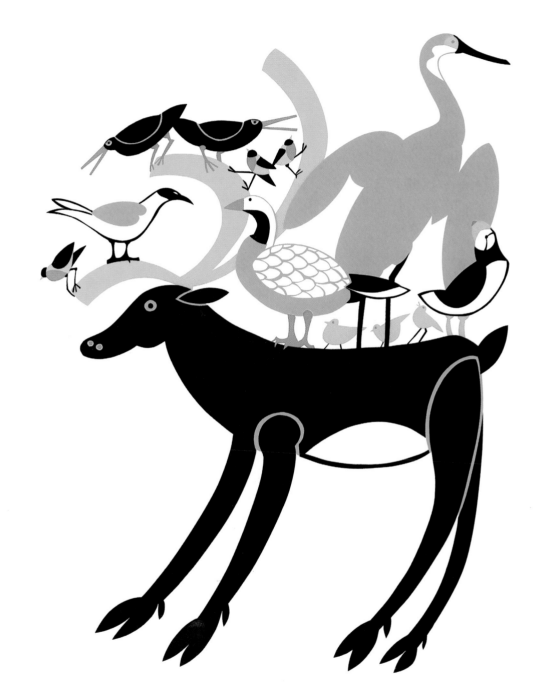

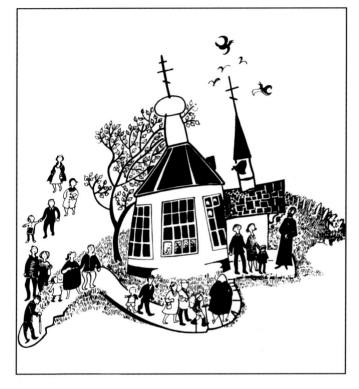

Roosting Birds
1983
Serigraph
Printer: Serigraphics
Albuquerque, New Mexico
12" X 15"

"Birds are among my favorite subjects. They seem especially well suited for serigraphs. It is unlikely that this group of birds would ever be seen together in one place, let alone roosting on the antlers of a caribou!"

Saint Nicholas Church
1976
Serigraph
Printer: J. Crondahl
Juneau, Alaska
13" X 13½"

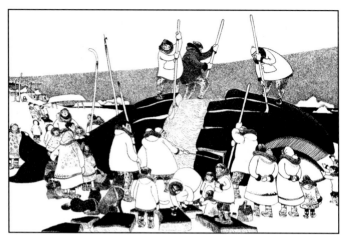

Butchering at Gambell
1974
Stone Lithograph
Printer: Tamarind Institute
Albuquerque, New Mexico
20¼" X 13"

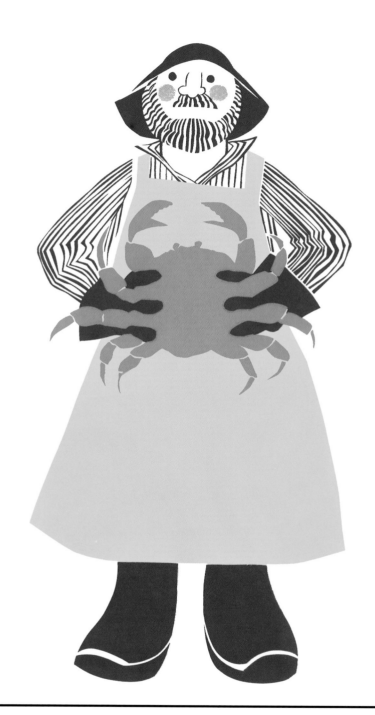

Dungeness Crab
1978
Serigraph
Printer: Prints and Panels
Juneau, Alaska
9⅝" X 18"

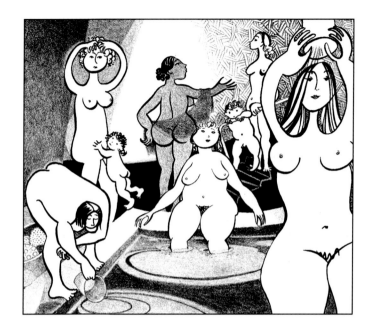

Ladies in the Bath, Tenakee
1975
Stone Lithograph
Printer: Atelier Deprest
Paris, France
10″ X 8¼″

"In Tenakee the day is built around the bathing hours at the hot springs. There is only one bath, so the women have their own hours. Since nearly everyone gets there at least once a day, it's a great place to socialize."

String Game
1980
Serigraph
Printer: Coriander
London, England
15″ X 21″

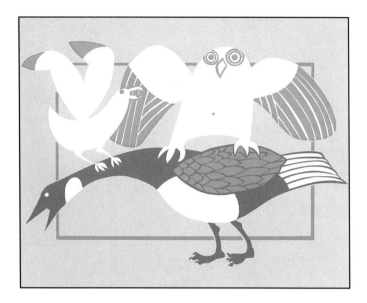

Some Alaskan Birds
1982
Serigraph
Printer: Prints and Panels
Juneau, Alaska
10¾" X 8⅛"

Eskimo Mother
1982
Stone Lithograph
Printer: Stone Press
Seattle, Washington
14½" X 19½"

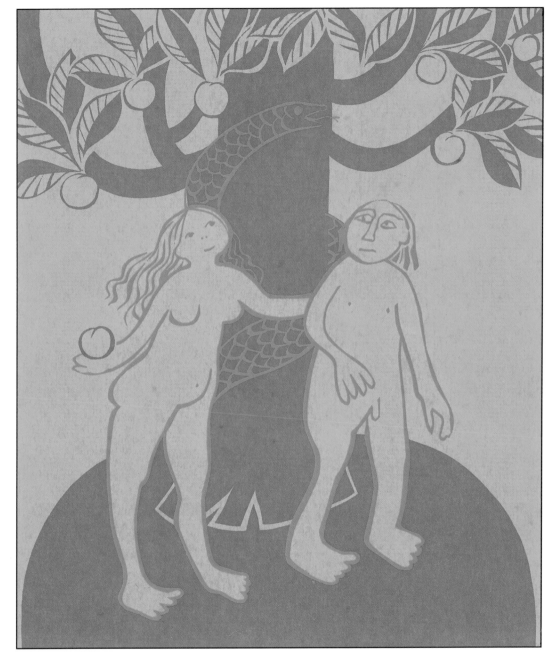

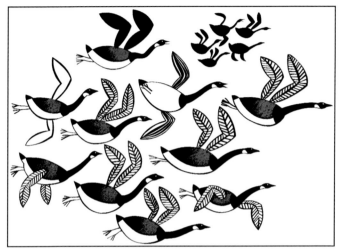

Migration
1977
Serigraph
Printer: J. Crondahl
Juneau, Alaska
20" X 14"

Temptation
1976
Serigraph
Printer: J. Crondahl
Juneau, Alaska
9" X 10"

"During a trip through Europe I saw so much religious art that I was inspired to do this biblical scene."

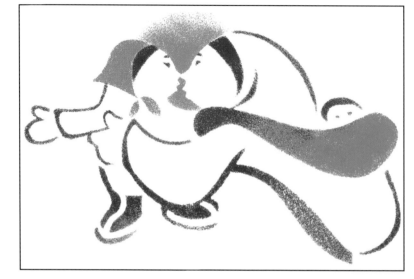

The Kiss
1971
Stencil
17" X 11"

"My first graphics were simple cut-out stencil designs where I applied the paint with a sponge."

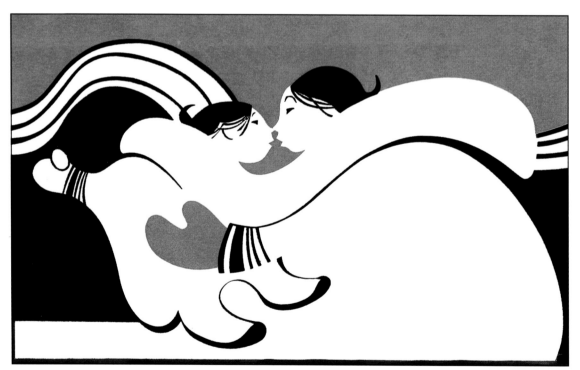

The Kiss
1978
Printer: Prints and Panels
Juneau, Alaska
Serigraph
12¾" X 7¾"

*"Seven years later, using the same basic design as above, I did a serigraph of **The Kiss**. Since then I have also used this design for an Aubusson tapestry."*

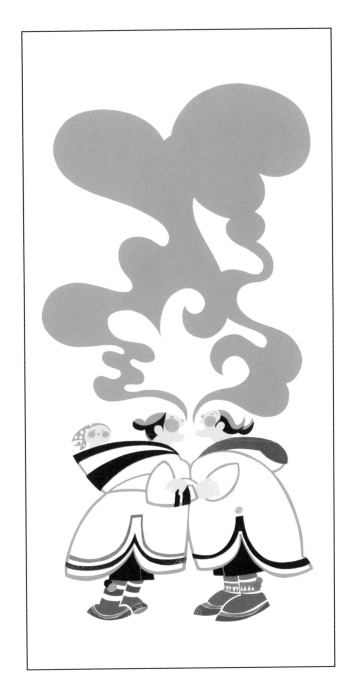

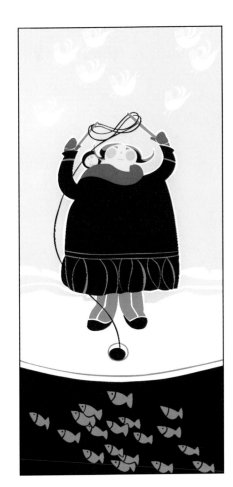

Spring Ice Fishing
1982
Serigraph
Printer: Serigraphics
Albuquerque, New Mexico
8⅛" X 18"

Throat Chanters
1986
Serigraph
Printer: Coriander
London, England
9½" X 19"

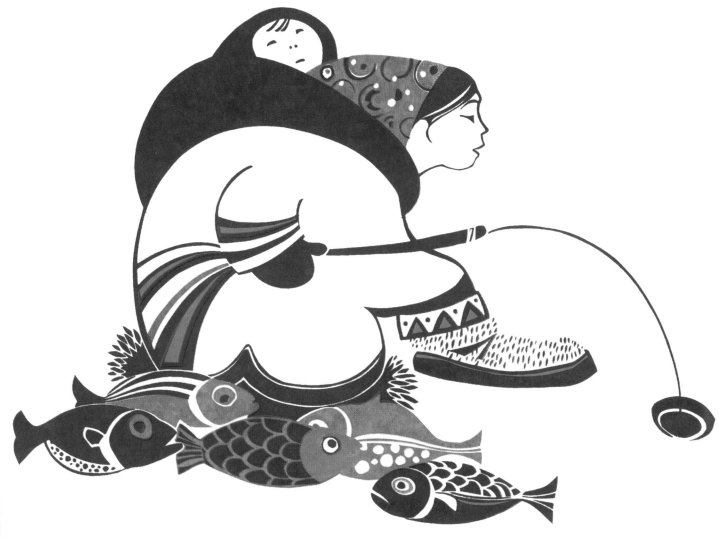

Ice Fishing
1976
Serigraph
Printer: J. Crondahl
Juneau, Alaska
14" X 10"

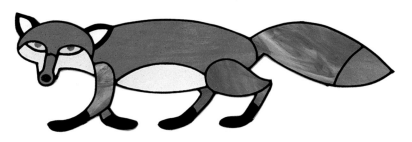

Tapestries and Stained Glass

Tapestries

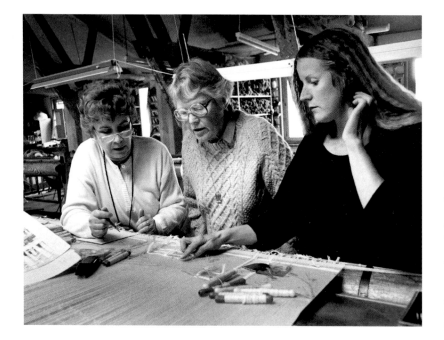

Rie Muñoz tapestries are woven in Aubusson, a small village in south central France, noted for its tapestry weaving since the 15th century.

Muñoz's role at Aubusson is to draw the cartoon or maquette, a blown-up pencil or color sketch of the design, to the exact size the tapestry is to be woven. She makes numerous notes on the cartoon to clarify the subtle areas, such as where strong shades are to fade into soft tones and vice-versa.

Colors for the tapestry are selected in a room filled from floor to ceiling with shelves stuffed with thousands of skeins of wool, all in different colors. Small strands of yarn that match the design are snipped off the skeins. These samples are sent off to the dyer who dyes the wool for each weaving. Often as many as 120 colors are used for a Muñoz tapestry.

(Left) Rie Muñoz inspects the work in progress on one of her Aubusson tapestries. Communication is made difficult by Muñoz's limited knowledge of French and the weaver's even more limited experience with English. (Below) An Aubusson tapestry is completely hand-woven. Depending on the complexity of the design, a month or more is needed to complete one square meter.

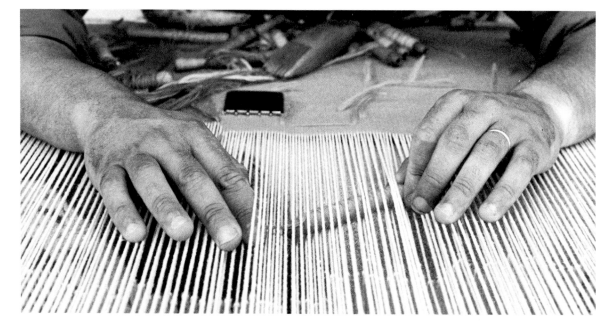

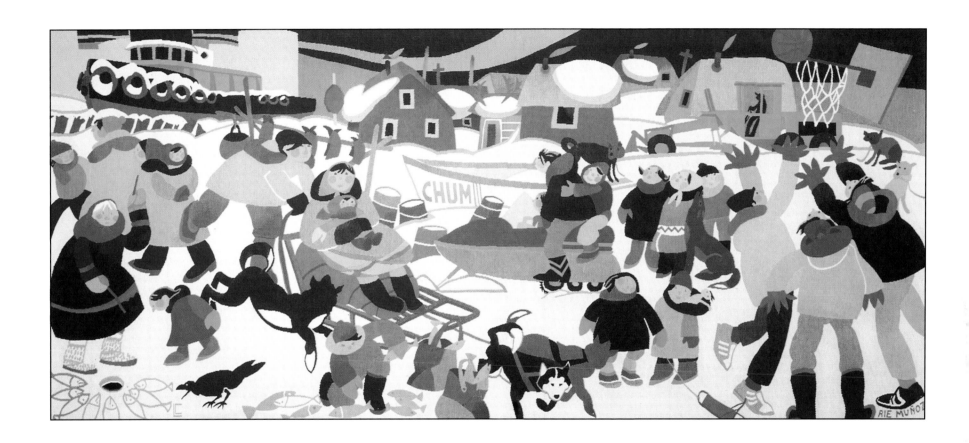

**Les Enfants de Kotzebue
(The Children of Kotzebue)**
1984
Woven by Atelier Camille
Legoueix
Aubusson, France
108" X 48"

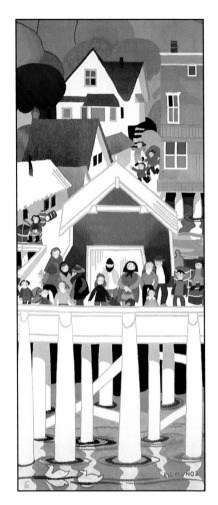

**Waiting For the Ferry,
Tenakee**
1986
Woven by Atelier Camille
Legoueix
Aubusson, France
48″ X 93.6″

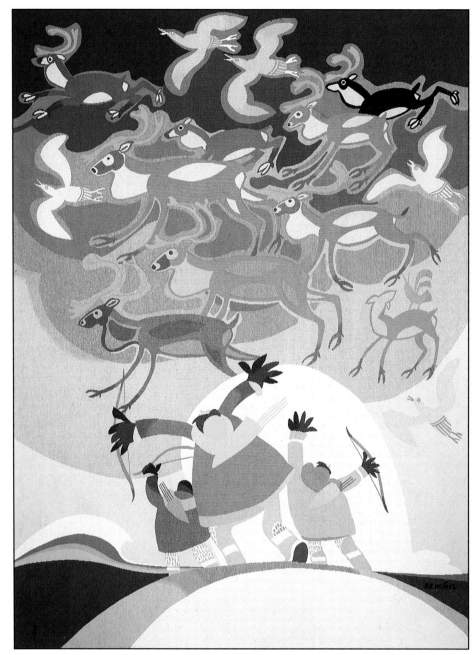

The Last Caribou
1982
Woven by Pinton Freres
Aubusson, France
72″ X 98.5″

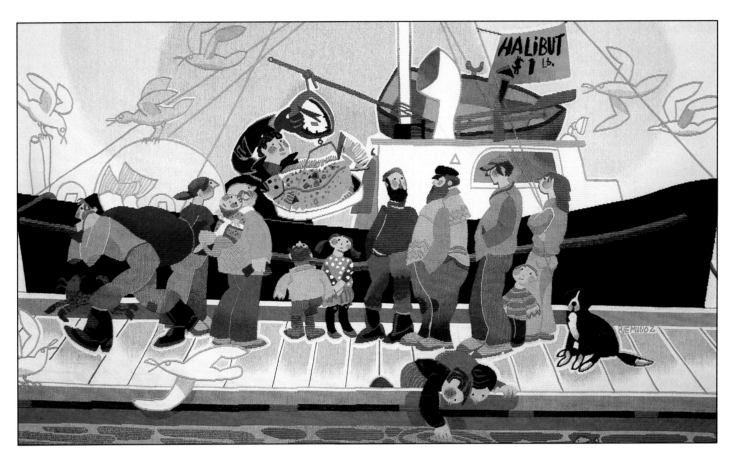

Halibut $1
1985
Woven by Atelier Camille
Legoueix
Aubusson, France
66" X 38"

Stained Glass

When a small fine-arts glass studio opened in Juneau, Muñoz was inspired to create her colorful characters in a new medium.

Often taking a simple detail from an earlier painting, Muñoz makes a cartoon or drawing to size for the design. Colors and types of glass are selected and then assembled by the artisans.

The pieces shown here were produced by The Glass Works in Juneau, Alaska.

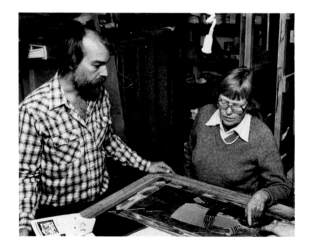

*(Top) Muñoz working on **Dungeness Crab**.*
(Left) The artist with glass artisan Bruce Elliot.

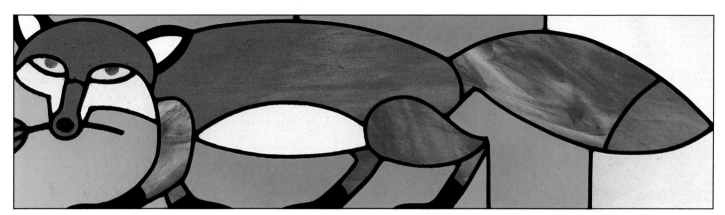

Fox
1984
30⅛" X 9½"

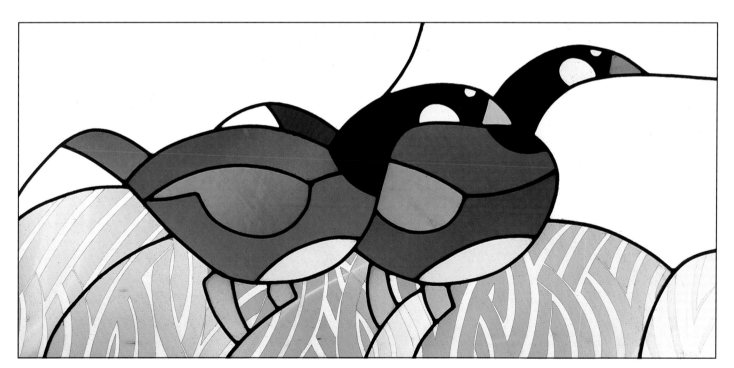

Geese
1984
34⅛" X 15¾"

Dungeness Crab
1984
20⅜" X 35⅛"

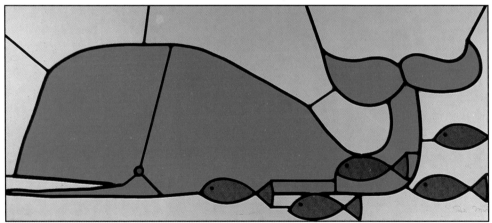

Whale
1986
32½" X 14⅛"

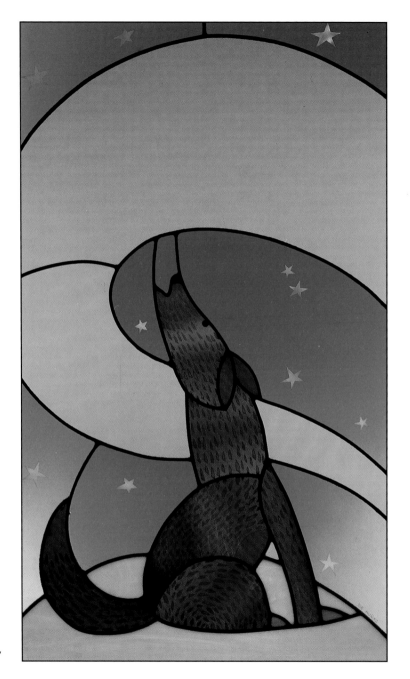

Howling Dog
1985
21¼" X 36¼"

Index

Index

Alphabetical Listing for Rie Muñoz: Artist in Alaska

Credits

Photographs of original work and stained glass by Dave Gelotte

Photograph pages 60 and 78 by Peter Metcalfe

Lower photograph page 78 by Yvonne Mozee

Photograph pages 13 and 30 by Mark Daughhetee

Rie Muñoz, Ltd. wishes to thank the private collectors who loaned their originals and stained glass windows for inclusion in this publication.

Thanks to the Alaska State Museum, Juneau, Alaska, for the use of their originals:
1. *Shoveling Snow*, page 27, Museum catalog #V-A-361
2. *Shaktolik General Store*, page 20, Museum catalog #V-A-364
3. *2nd Hand Store*, page 27, Museum catalog #V-A-526
4. *Divine Liturgy, Eklutna*, page 10, Museum catalog #V-A-366

Special thanks to Peter Metcalfe for his assistance with this project

Rie Muñoz, Ltd.
Juneau, Alaska
(907) 586-2112

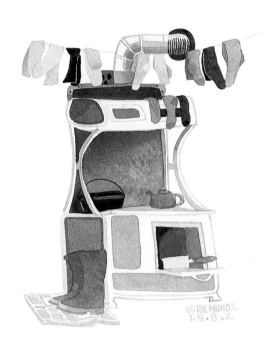